Cool

by Jo Levin

For Richard

First published in Great Britain in 2000 by
PAVILION BOOKS LIMITED
London House, Great Eastern Wharf
Parkgate Road, London SW11 4NQ
www.pavilionbooks.co.uk

Art Direction and Design by Tony Chambers

A CIP catalogue record for this book is
available from the British Library.

ISBN 1 86205 3960

Colour origination by Colourpath, England.
Printed and bound in Italy by Editoriale
Johnson, Bergamo.

10 9 8 7 6 5 4 3 2 1

This book can be ordered direct from
the publisher. Please contact the Marketing
Department. But try your bookshop first.

Front cover: (clockwise from top left)
Keith Richards by Peter Lindbergh,
Lawrence Fishburne by Peter Lindbergh,
John Travolta by Peter Lindbergh,
David Bowie by Peter Robathan,
Ronaldo by Peter Lindbergh,
Ewan McGregor by David Eustace,
Beck by Dana Lixenberg,
John Simm by Donald Christie

Back Cover:
David Beckham by Julian Broad,
Liam Gallagher by Julian Broad,
Samuel L Jackson by Peter Lindbergh

PAVILION

I bet everyone in this book looks good in blue denim jeans

When I hit fourteen, that's nearly forty years ago, James Dean walked the streets of Bromley in all his mysterious sizes. Short, tubby, long and lanky or bespectacled and curly haired. Everyone wanted to be him.

I did my best. From the waist up that is. I romanced denim with all my heart and soul, did all the right things like wearing them in the bath and sitting around in them till they dried and shrank. They just would not give it up. They would not be cool on me. It's as if I only got to wear them on their day off. On 'Don't Be Cool Day'. On me they were just pieces of tubular blue stuff. I expect that's why, throughout my life, I've so often drifted into the sartorial beyond. It's out of revenge.

But the circle closes now, in this, the twenty first century. For when the gazelles and gonzos in this tome leave the photo studio, their designer duds heaped in the arms of weeping stylists, they will effortlessly subjugate themselves to the dictate of Mr. Strauss and his followers. They deserve our compassion, for I know now that I am one of the few, around whom 'relaxed' denim certainly and irrevocably – isn't.

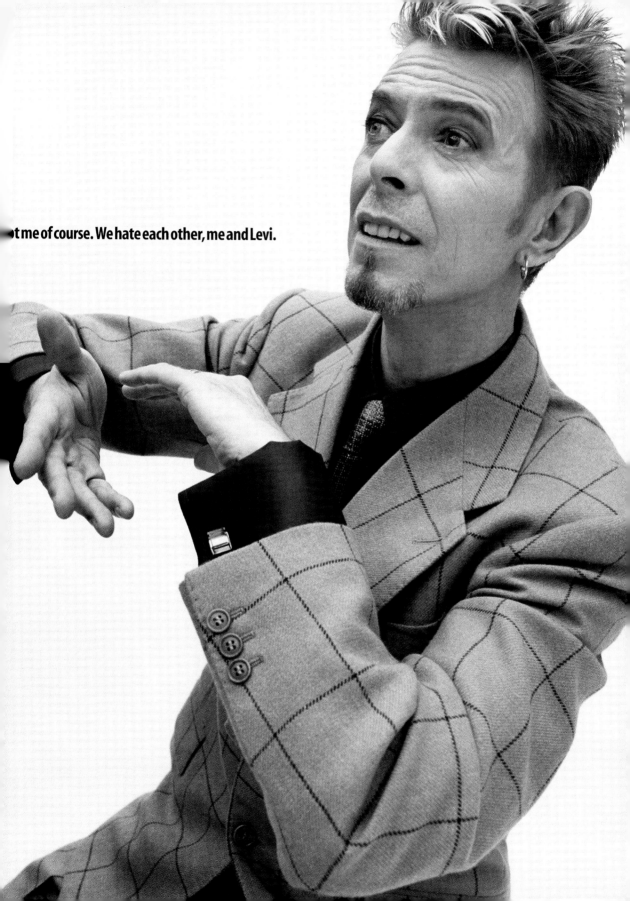

t me of course. We hate each other, me and Levi.

Introduction
by Dylan Jones

The legend set down his rather large tumbler of vodka and fizzy orange and looked in my direction, if not fairly squarely in the eye. Because of the hastily arranged drapes covering his hotel room windows it was difficult to make out his mood, but his mouth said it all. "Hats off man, they rock. You know what I'm saying? These pictures really rock."

Keith Richards is not wrong. The pictures do indeed 'rock' – a set of magnificent Peter Lindbergh fashion portraits shot on the rooftops of midtown Manhattan for an heroic 12-page story in GQ's 1999 Men Of The Year issue. That year, GQ readers voted the fifty-something Rolling Stone the legend most deserving of the Lifetime Achievement award ('Maaaan Of The Year,' actually), inheriting the title from another legendary Brit, Michael Caine. Throwing shapes against the Gotham skyline – just minutes before it began to rain – the Human Riff showed off his Gianfranco Ferre overcoat and black Gucci jeans with great aplomb, proving that 40 years of drink, drugs and debauchery haven't affected his judgement of what constitutes a truly great picture.

Some of these remarkable pictures are reproduced here, in what we hope you'll agree is a collection of some of the best fashion and celebrity photographs taken in the last ten years – GQ's Greatest Hits.

John Travolta looking mean and serene; Lemmy playing disconcertingly with a rifle; Iggy Pop in full make-up; Ronnie Wood resplendent in the back of a limo; a bare-chested Ronaldo; a leather-clad David Beckham; Max Beesley dancing like a dervish; Hugh Grant nonchalantly smoking a cigarette; a shorn-haired Ewan McGregor; Danny DeVito; Danny Boyle, Bowie and D'Angelo. Plus Brett Anderson, Boy George, Arnold Schwarzenegger, Ronan Keating, Liam Gallagher, Beck, Roman Polanski, Tom Jones, Andy Williams, Sean Ryder, Paul Simenon, Marcello Mastroianni, Bryan Ferry, Gaz Coombes, Goldie, Elvis Costello, Samuel L Jackson, Matt Dillon, Wyclef Jean, Tim Roth et al. And dozens of cool-looking guys in sharp-looking suits acting as if they were stars in their very own movies.

What all the people in this book possess is an innate sense of cool, a sense of their very own particular style. Cool is a term which has become something of a pejorative of late, but all those included here have it in spades. Cool looks. Cool clothes. Cool hair. Cool... well, pretty much cool everything. Cool has always been an abstract, almost subjective concept, and because it has become rather more codified of late, those who possess it have even more status. The kind of status which shines through in these pages, a status – a coolness – that is inherently only about one thing: style.

For over ten years, GQ has been redefining male style through the work of the world's very best fashion photographers. There are many men's magazines which purport to represent men's fashion but none which have GQ's renowned world-wide authority. As the most important men's magazine brand in the world, GQ commands only the very best fashion photographers, producing work unrivalled by any of our rivals. What Vogue does for womenswear so GQ does for menswear.

Since it was launched by Condé Nast in 1988, GQ has endeavoured to live up to its name: the most established quality men's magazine brand in Britain, the bestselling, and – simply – the best. What else would you expect from the publishers of *Vogue*, *Vanity Fair*, *The World Of Interiors*, *Condé Nast Traveller*, *Brides*, *Tatler* and *House & Garden*?

In Britain, so it seems, a new fashion magazine is launched every five minutes; magazines which claim they will 'reinvent fashion photography'; magazines which try and push the cutting edge way over the horizon; or magazines which simply try and copy everyone who came before them. And, sometimes, magazines which foolishly attempt to do all three. Fashion photography is also becoming somewhat blurred, if you get my drift. These days it seems to encompass everything from news-driven photo-reportage and photo-realism to experimental portraiture and hi-gloss pornography. Today, anything goes, so paradoxically everything tends to look the same. Nowadays a lot of fashion and celebrity portraiture appears to be more about the photographer than the subject; more about the stylist than the clothes; more about the technique than the results. And to what avail? As Tom Stoppard put it in his play, *Artist Descending A Staircase*: 'Imagination without skill gives us contemporary art.' Or photography.

Which makes it all the more important for iconic mainstream magazines to reaffirm the traditional, classic mechanics of image-making. To reinforce the fundamentals of cool. And to stay several steps ahead of everyone else. Which is what British GQ tries to do – with some success, I might add – each and every month.

By mixing the modern, the innovative and the forthright with the classic, the chic and the

incontrovertible, GQ has become the standard-bearer of contemporary cool, the ultimate affirmation of iconic male imagery. Modern and classic, old and new, classic with a twist – call it what you will, nobody does it better. Which is why we've produced this book, GQ's greatest visual hits.

The Keith Richards pictures, like most of the others in this book, were styled by the remarkable Jo Levin, GQ's fashion director since 1992. Jo has made iconography something of an art form, taking the oft-celebrated heroes of the modern age and somehow managing to deify them in ways even their publicists couldn't imagine. This book could easily have been called *Fashion Direction*, for many of the photographs here have a cinematic quality to them, even the ones which feature no famous names at all. Jo is, after all, rather more than a fashion director, imbuing her images with a lasting quality that endures with age. Photographs of men in clothes are not in themselves intrinsically fascinating; Jo's job is to make them so. By choosing only the very best clothes, the very best photographers, and by using the very best creative teams. Jo Levin is the consummate professional, and if there are harder-working fashion directors in menswear I don't know of them. I've known Jo as a friend and as a colleague for nearly a decade and during that time I've never known her to be anything less than totally charming, even if she's in the process of telling a fantastically famous person that unless they stop behaving like a baby then they're not going to know what hit them. Not that Jo would ever hit anyone – she's far too much of a lady for that. But I wouldn't push her if I were you. She is, as British Condé Nast Managing Director Nicholas Coleridge has said, time and time again, GQ's secret weapon. Or, as Richards says himself, "That chick is cool, man." High praise indeed.

"When I came to GQ I wasn't doing menswear, but I really had a problem with all these chisel-jawed, moody male models who were all over the magazines," says Jo. "I wanted to photograph real men, famous or not. I thought, why not photograph Wim Wenders walking through the streets of Berlin, for instance, and he just so happens to be wearing a Yohji Yamamoto coat? I was fed up with looking at pictures of silly-looking men. I wanted to photograph talented men, real men with style. What's so wrong with real life?"

"I love photography and I love photographers, and I wanted to use them properly rather than just as accessories. I wanted to move away from the catalogue feel of fashion photography. I wanted to capture something extremely male and extremely sexy. I wanted to shoot men who are good at what they do – actors, musicians, whatever. And other men like looking at successful men. Not a clotheshorse. Clotheshorses are boring. Sport, theatre, jazz, the military, whatever. Talent has become GQ's point of difference. Talent is very sexy."

Who else but Jo Levin could command an army of photographers that has included **Peter Lindbergh, Paolo Roversi, David Eustace, Matthew Donaldson, Terence Donovan, Koto Bolofo, Julian Broad, Magnus Marding, Peter Robathan, William Claxton, Dana Lixenberg, Laura Wilson, Hanspeter Schneider, The Douglas Brothers, Guzman, Richard Burbridge, Jeffrey Mermelstein, Olivia Beasley, Albert Watson, Michael Roberts, Desmond Muckian, Wayne Maser, Tim Richmond and Stephanie Pfriender?**

This dedication to fantastic fashion photography, coupled with top-end journalism by the likes of AA Gill, Tom Wolfe, Tony Parsons, Will Self, Adrian Deevoy, David Mamet, Rob Ryan, Irvine Welsh, Jim White, Cosmo Landesman, Martin Deeson and Philip Norman, as well as Simon Kelner (Editor of *The Independent*), Robin Morgan (Editor of the *Sunday Times Magazine*), Rowan Pelling (Editor of the *Erotic Review*) and Boris Johnson (Editor of *The Spectator*) makes GQ the only men's magazine for grown-ups, the only men's magazine with fire in its belly and freshly-polished brogues on its feet.

It's big. It's clever. It's grown-up. And also rather cool. Keith Richards certainly thinks so. He said it best when he first saw his GQ portraits. "You know man?" he told me, playing with his rings as he absent-mindedly sprinkled the pristine hotel carpet with cigarette ash, "You've made me look like Keith Richards. And believe me, that's not as easy as you might think."

Precisely.
Dylan Jones is Editor of GQ.

music

01

Can you be pop without cool, can you scale the giddy heights of the music business without being hip to that sort of trip? Ever since Elvis bought his first seersucker drape and rubber-soled correspondent shoes, the world has demanded a certain sense of style, particularly from those who are relatively new to the game. Fashion, turn to the left! Fashion, turn to the right...

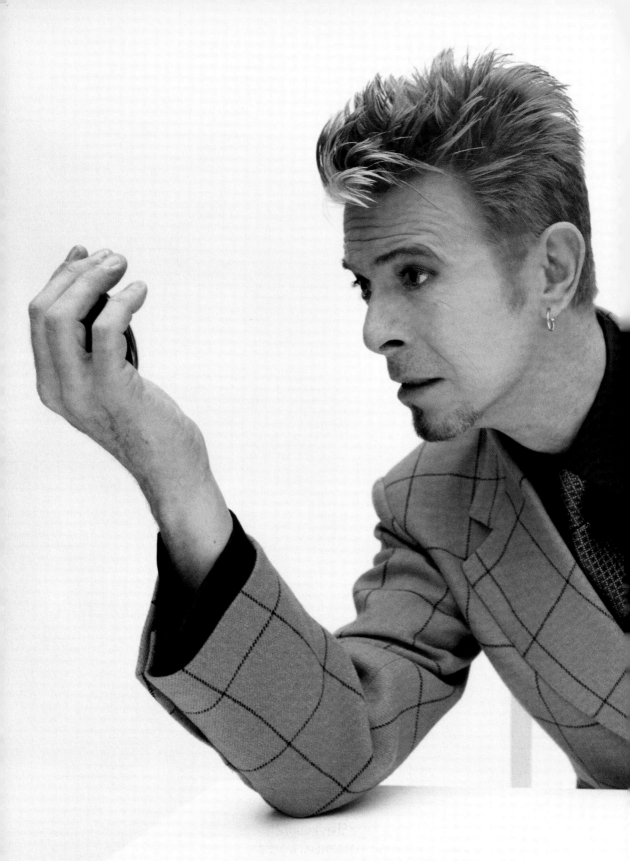

David Bowie

5 August 1997 London
Peter Robathan

This shoot came about in Paris after a conversation with designer Paul Smith. He's been a friend of David's ever since he designed the trousers that Bowie wore on the cover of Hunky Dory. *Anyway, the night before, I'd had a stylist's nightmare. I turned up at the studio with my trunk full of clothes and began unpacking. To my horror I pull out pink and blue crochet dresses instead of Paul Smith suits. I woke up in a terrible sweat. The next day I retold my story to David and he laughed and said, "Jo, now we could have had some fun with that."*

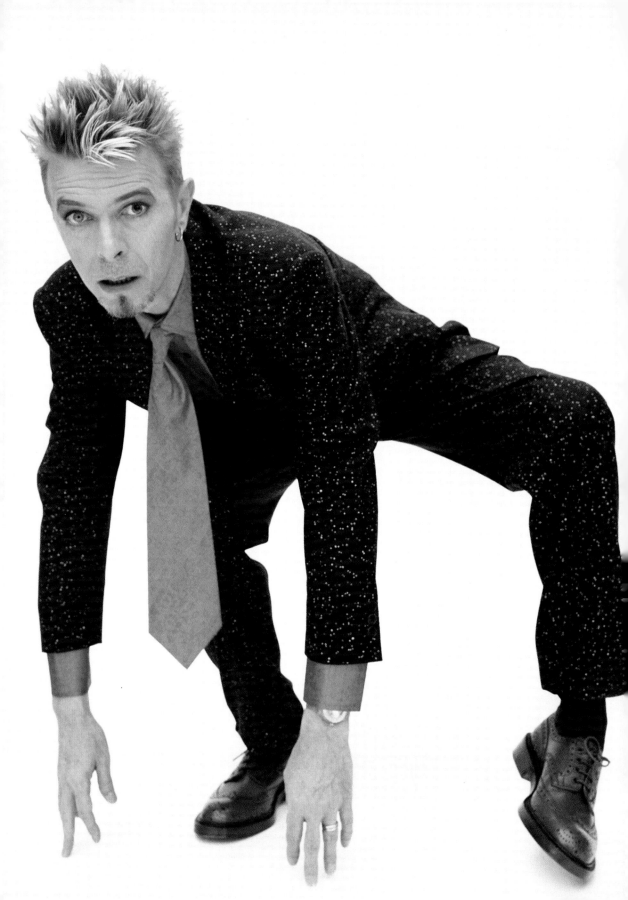

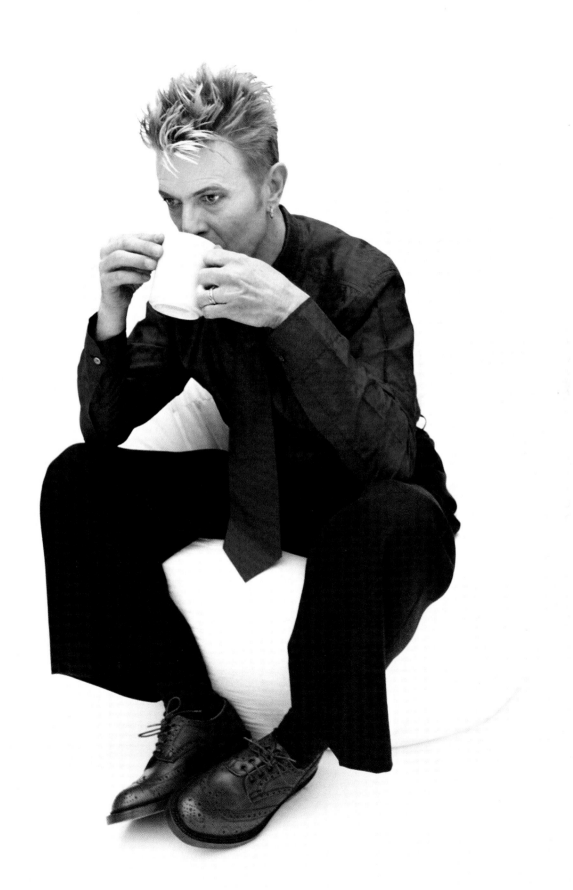

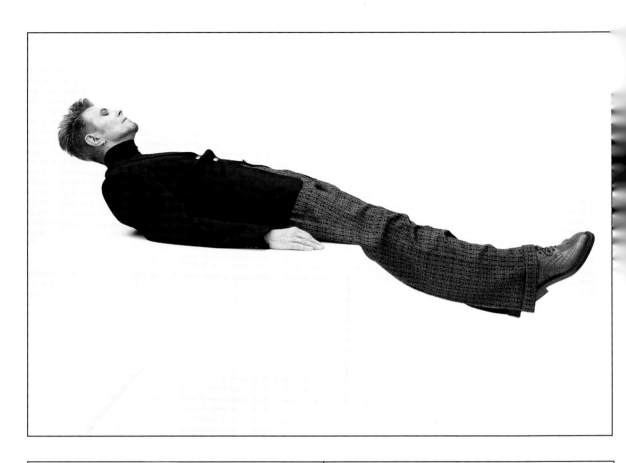

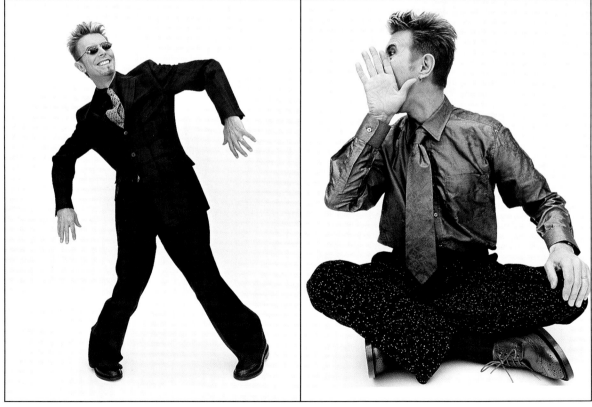

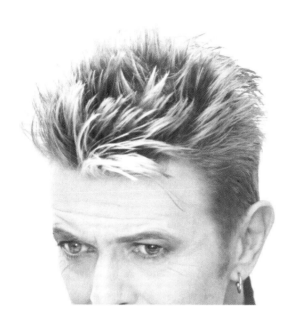

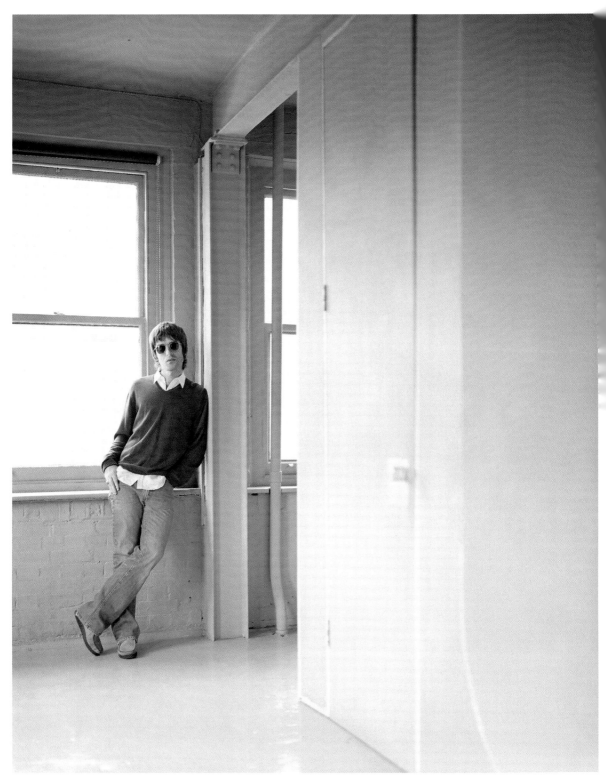

Noel Gallagher
23 November 1999 London
Matthew Donaldson

This was the first proper photo session that Oasis had done for three years, and they chose to do it with GQ. Noel actually refused to have a stylist tinker with him, though we surrounded him with an army of our people to make sure nothing went awry. As it was he seemed to have a fantastic time; he was photographed without his brother.

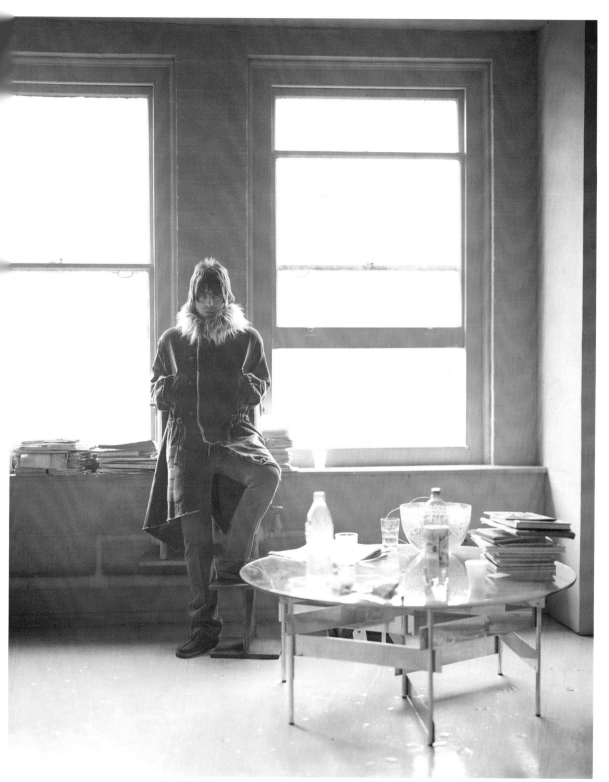

Liam Gallagher
23 November 1999 London
Matthew Donaldson

Liam had arrived earlier in the day, and also seemed to be in fine fettle, even though he couldn't stop talking about his brother. "The photographer's better off with just me in the picture," he said.

"Noel's bound to spoil it with his Adidas trainers and Prada jacket."

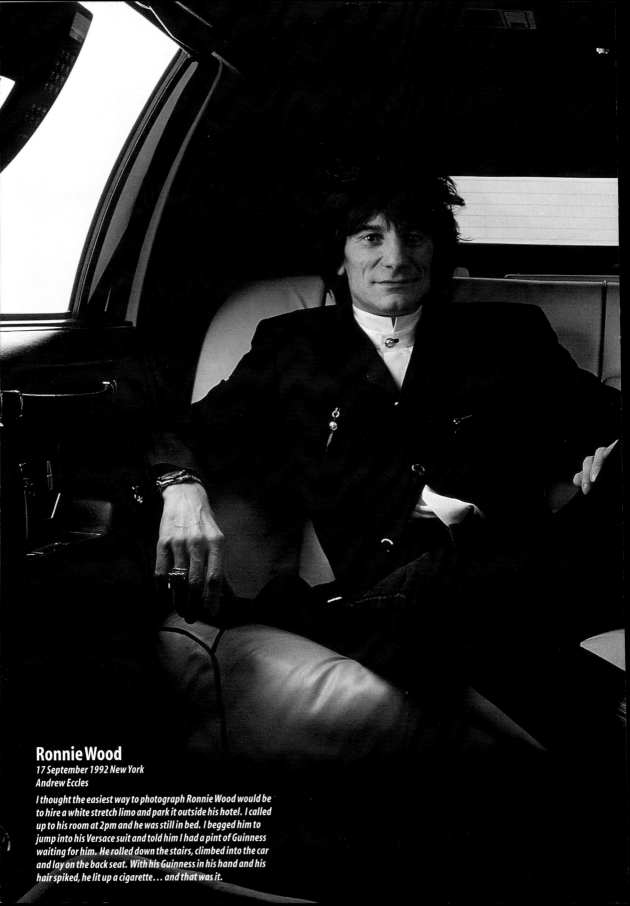

Ronnie Wood

17 September 1992 New York
Andrew Eccles

I thought the easiest way to photograph Ronnie Wood would be to hire a white stretch limo and park it outside his hotel. I called up to his room at 2pm and he was still in bed. I begged him to jump into his Versace suit and told him I had a pint of Guinness waiting for him. He rolled down the stairs, climbed into the car and lay on the back seat. With his Guinness in his hand and his hair spiked, he lit up a cigarette… and that was it.

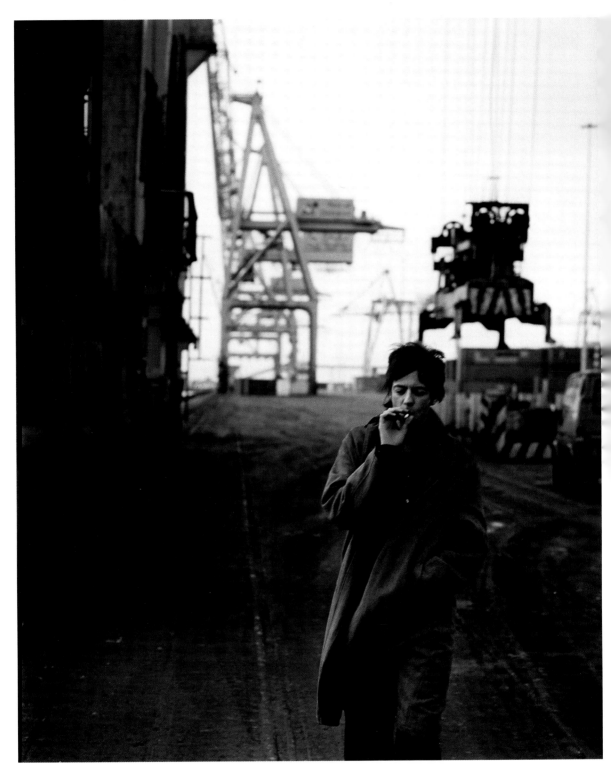

Ian McCulloch
21 May 1996 Liverpool
The Douglas Brothers

After a day spent shooting on the Liverpool docks with The Douglas Brothers,
we ended up in Ian's kitchen eating fish and chips from the local chippy.

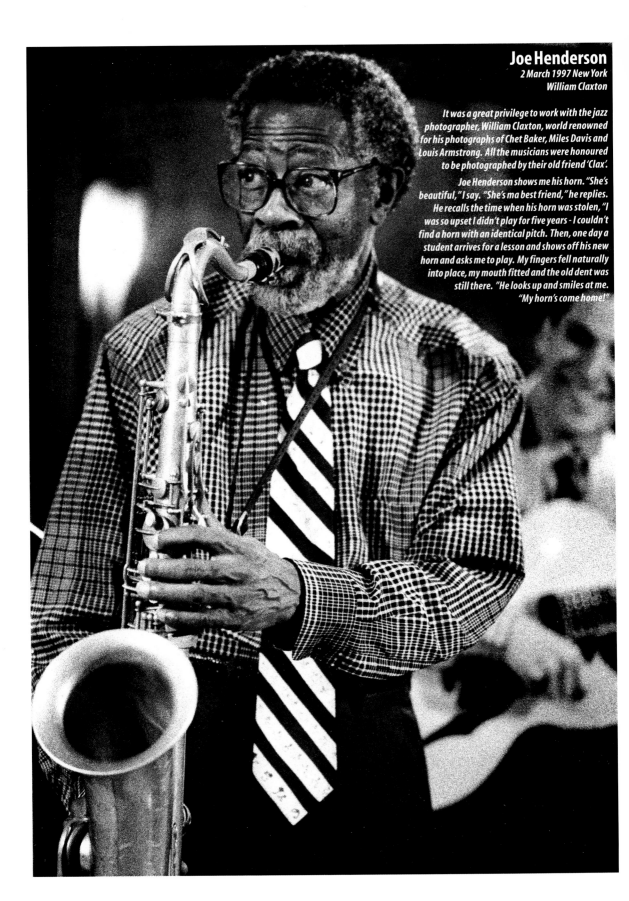

Joe Henderson
2 March 1997 New York
William Claxton

It was a great privilege to work with the jazz
photographer, William Claxton, world renowned
for his photographs of Chet Baker, Miles Davis and
Louis Armstrong. All the musicians were honoured
to be photographed by their old friend 'Clax'.

Joe Henderson shows me his horn. "She's
beautiful," I say. "She's ma best friend," he replies.
He recalls the time when his horn was stolen, "I
was so upset I didn't play for five years - I couldn't
find a horn with an identical pitch. Then, one day a
student arrives for a lesson and shows off his new
horn and asks me to play. My fingers fell naturally
into place, my mouth fitted and the old dent was
still there. "He looks up and smiles at me.
"My horn's come home!"

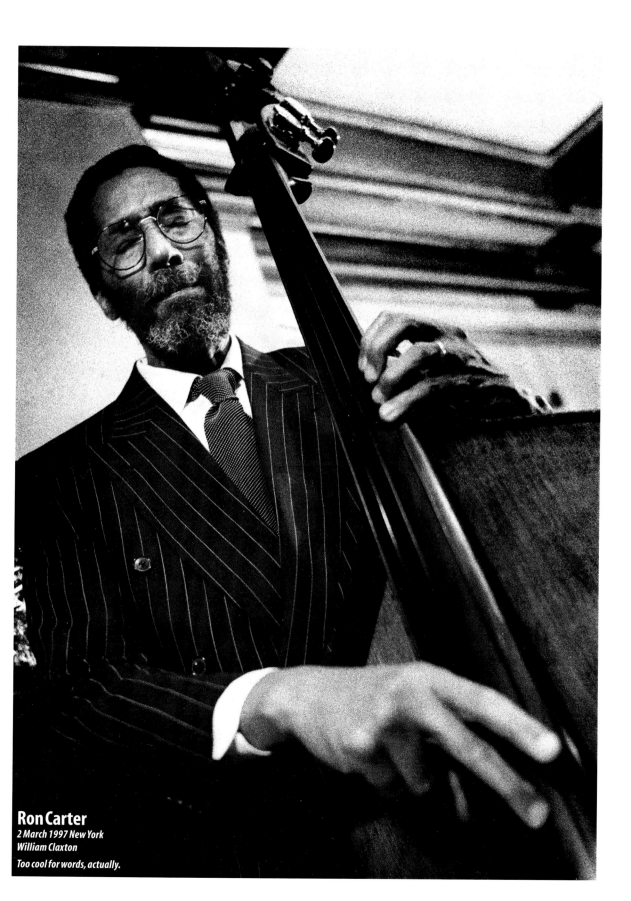

Ron Carter
2 March 1997 New York
William Claxton
Too cool for words, actually.

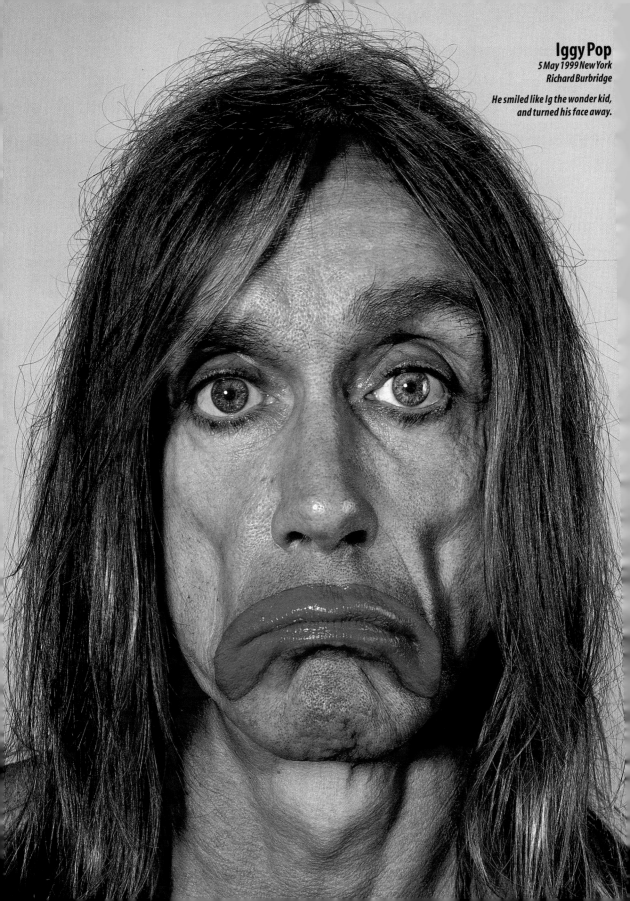

Iggy Pop
5 May 1999 New York
Richard Burbridge

He smiled like Ig the wonder kid,
and turned his face away.

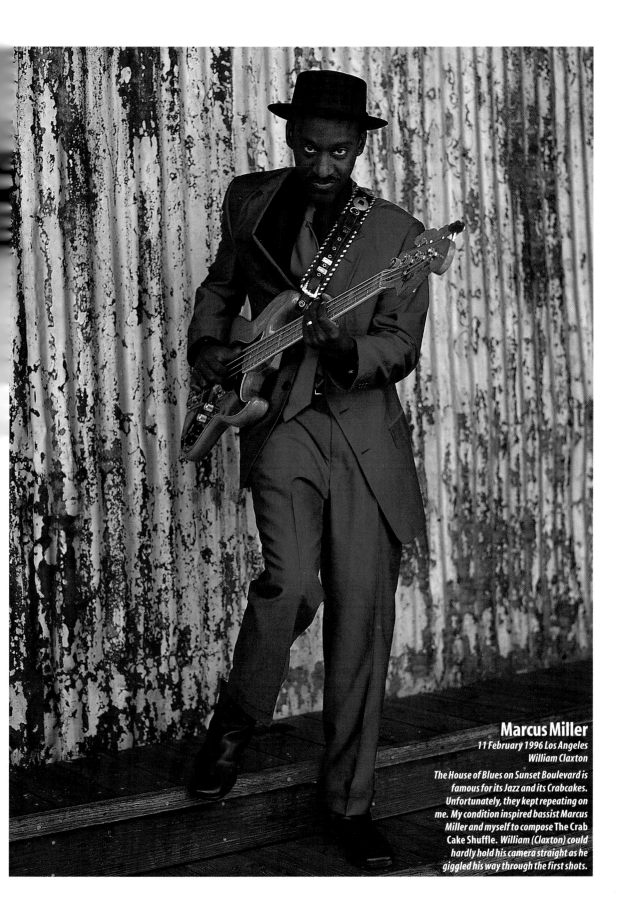

Marcus Miller
11 February 1996 Los Angeles
William Claxton

The House of Blues on Sunset Boulevard is famous for its Jazz and its Crabcakes. Unfortunately, they kept repeating on me. My condition inspired bassist Marcus Miller and myself to compose **The Crab Cake Shuffle.** *William (Claxton) could hardly hold his camera straight as he giggled his way through the first shots.*

Brett Anderson

22 December 1999 London
Dana Lixenberg

Three days before the shoot I was requested to
turn up at his house with the clothes for a
fitting. I arrived, Brett answered the door, I said,
"There are not many people I bring the
fashion cupboard to – you and Alan Rickman!"

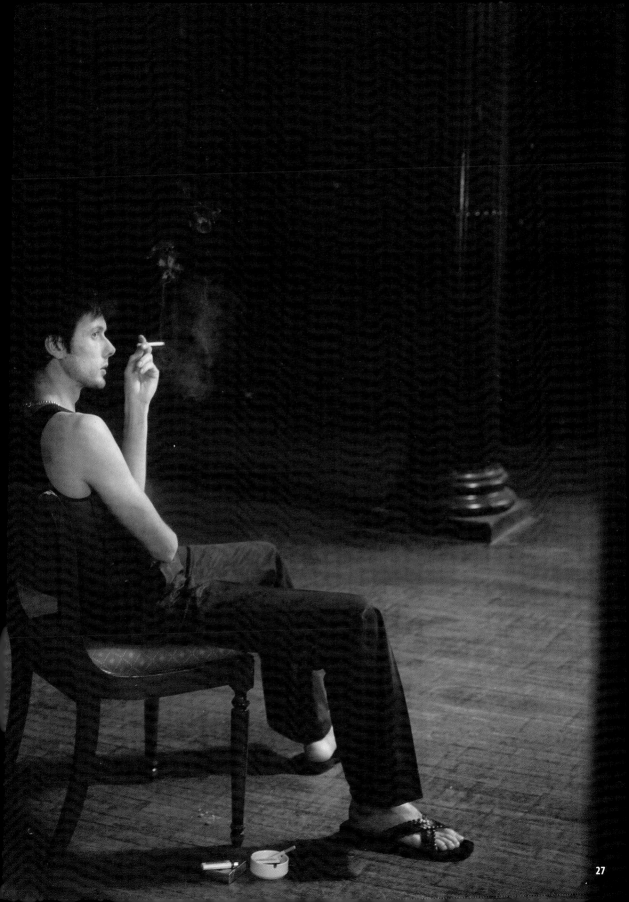

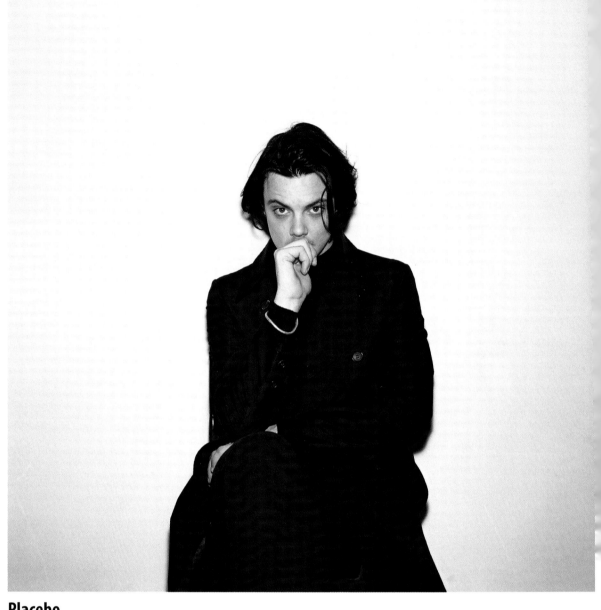

Placebo

16 February 1997 London
Julian Broad

Brian Molko, Stefan Olsdal and Steve Hewitt.
Lead singer Brian Molko forgot his
foundation so my assistant Gareth Scourfield
trawled the local chemists on Putney High
Street in search of Max Factor's Beautiful Skin
in Ivory-Beige. And he insisted on wearing
my pearl necklace.

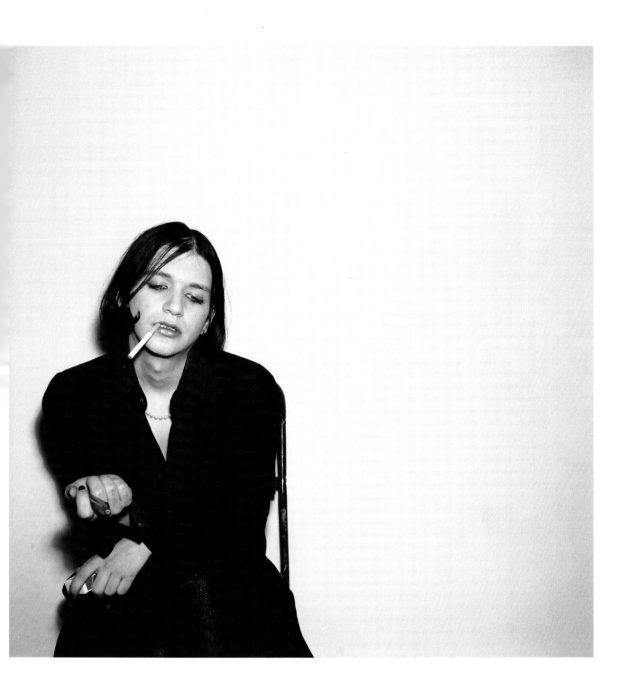

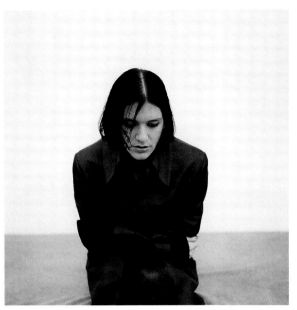
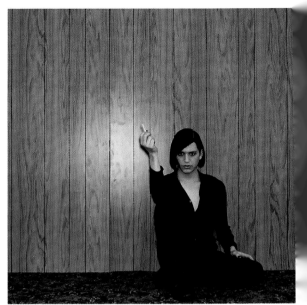
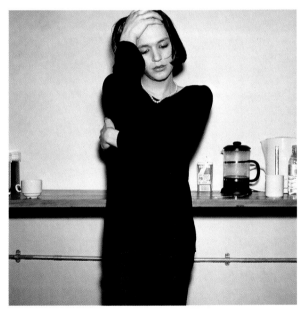

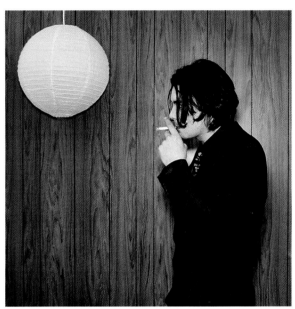
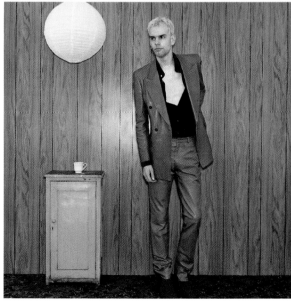

Terence Donovan portfolio

June, July & August 1996 Londo

This was Terence's last summer. We had a magical s...
months working together on the portfoli
Whenever Terence stood behind his giant tripo
preparing to zoom in for a portrait shot, he reminde
me of a ship coming into harbour, his camer
equipment clanking as it moved towards the sitte

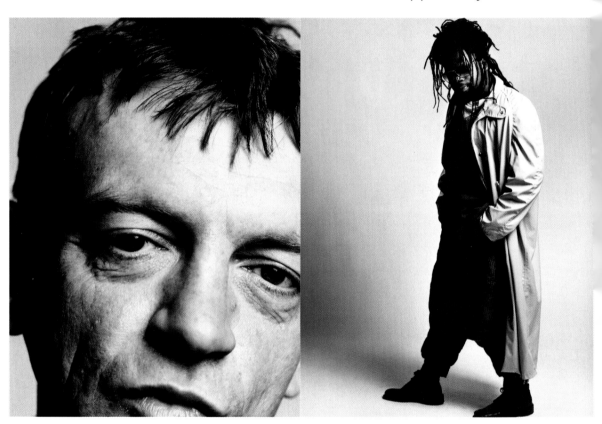

Mark E Smith
29 July 1996

He was the only musician
that Terence didn't get on with.
Hardly surprising, really.

Jazzie B
2 August 1996

All he did was dance – dance,
dance, dance, dance.

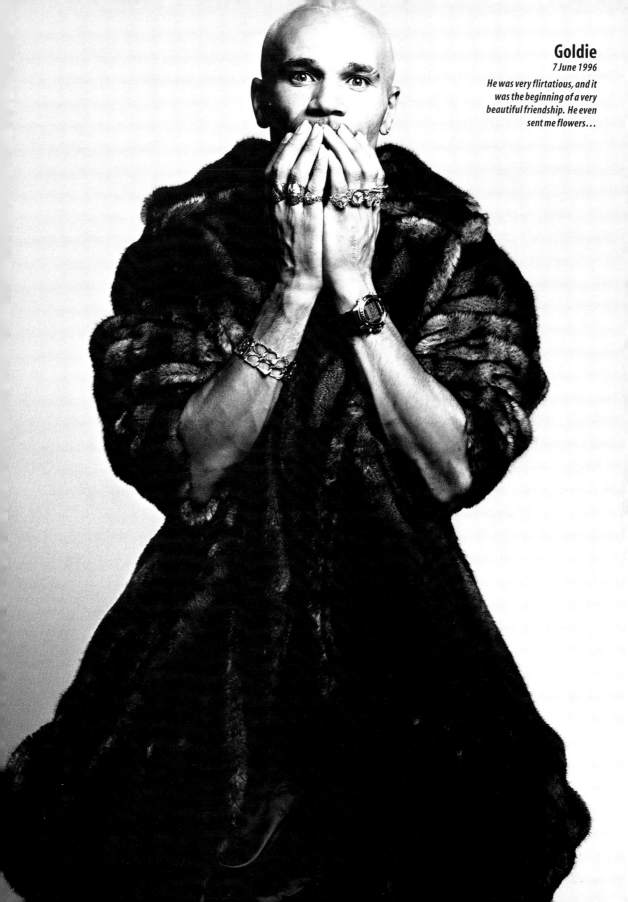

Goldie
7 June 1996

He was very flirtatious, and it was the beginning of a very beautiful friendship. He even sent me flowers…

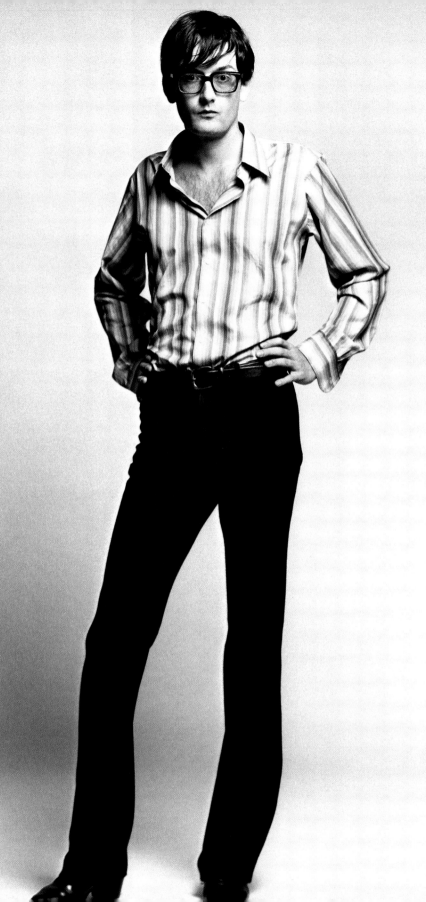

Jarvis Cocker
8 June 1996

He had a dirty collar, so I told him he should be ashamed of himself.

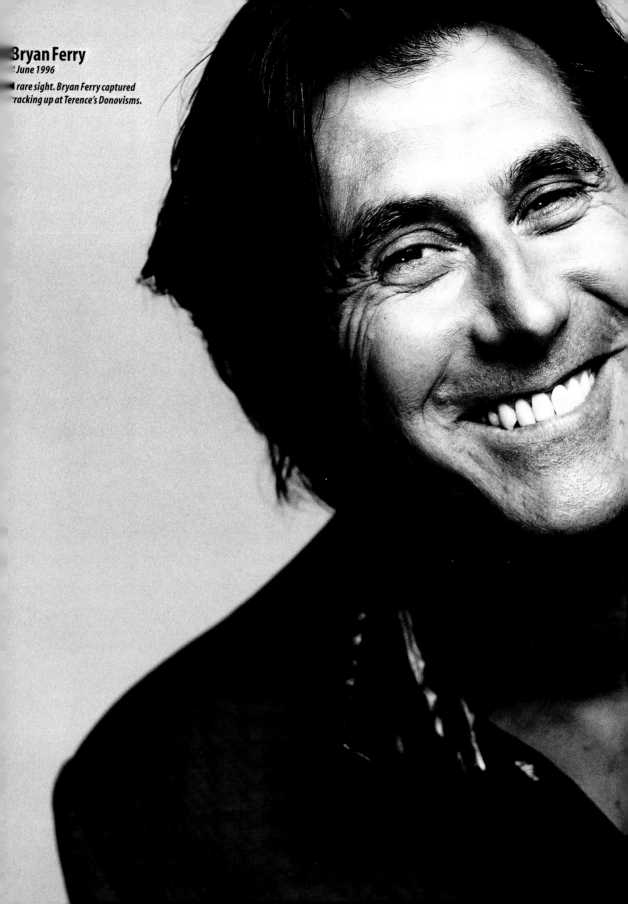

Bryan Ferry
June 1996

A rare sight. Bryan Ferry captured cracking up at Terence's Donovisms.

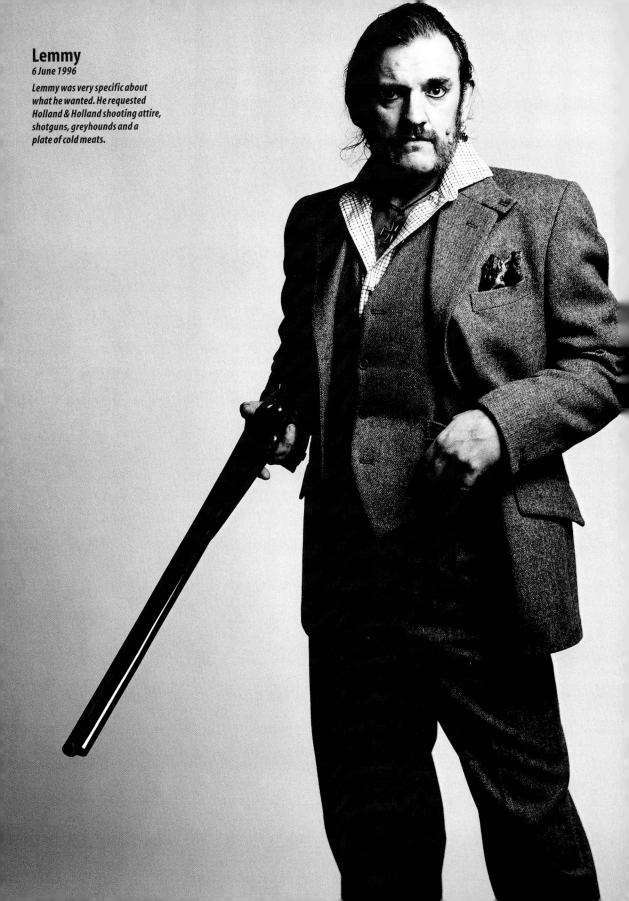

Lemmy
6 June 1996

Lemmy was very specific about what he wanted. He requested Holland & Holland shooting attire, shotguns, greyhounds and a plate of cold meats.

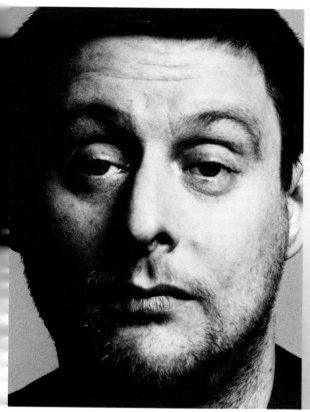

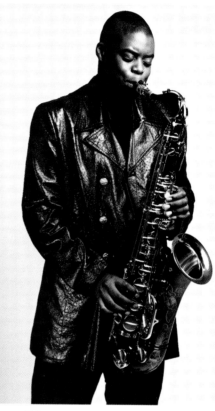

Sean Ryder
7 June 1996

He stank when he arrived then disappeared into the loo. When he came up he shouted "I'm Alive!" Afterwards he could barely stand up.

Courtney Pine
5 June 1996

When we shot Courtney Pine, Terence excitedly fished out a tape by Earl Bostic and had Courtney Pine jamming along – Terence warned us, "Don't tell too many people about this Earl Bostic, I don't wan' it to become commercial."

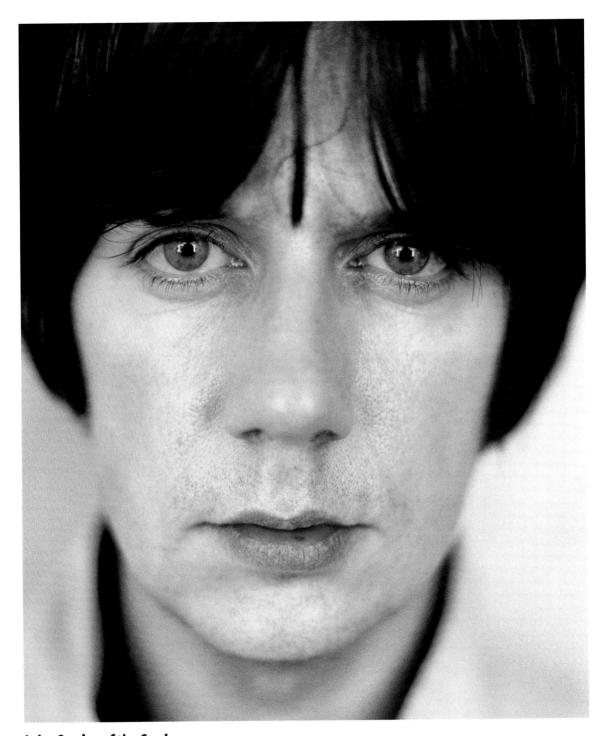

John Squire of the Seahorses
19 September 1997 London
Stephan Ziehen

*He seemed to think that every outfit made him look
as though he was wearing a pair of pyjamas.*

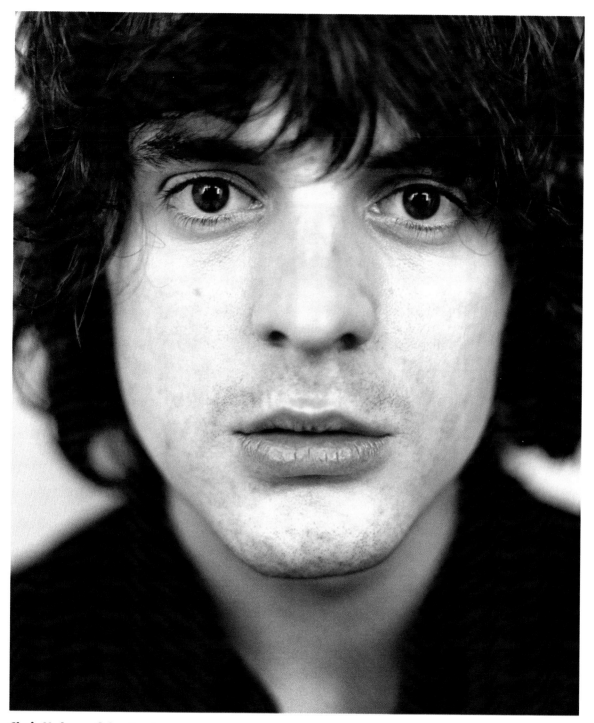

Chris Helme of the Seahorses
19 September 1997 London
Stephan Ziehen

Ditto.

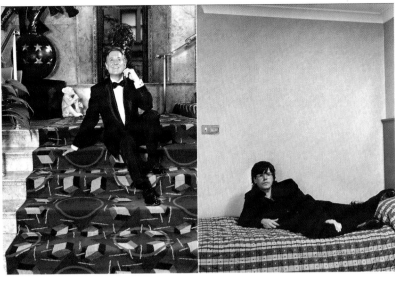

Tim Burgess
15 October 1999 London

*I told him about all the other people
we were shooting for the story
and he kept saying, "Without them
we wouldn't be here."*

Neil Sedaka
20 July 1999 New York

*During the shoot at his favourite
New York restaurant, Le Cirque, I asked
Neil to sing* Breaking Up Is Hard To Do.
*With a click of his fingers and a tap of
his toe he broke into song.*

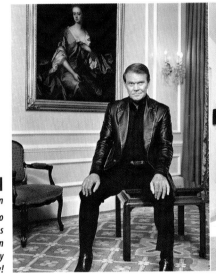

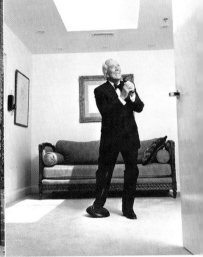

Glen Campbell
16 October 1999 London

*Glen Campbell is another GQ man who
was charm personified. The day was
complete after his induction to an
authentic English cream tea. I can safely
say he is now a Rhine scone cowboy!*

Andy Williams
24 July 1999 Branson, Missour.

*We photographed Andy Williams at his
theatre, the Moon River. The classic crooner
grabbed the mic and sang my favourite
song,* Music To Watch Girls By. *Dana and
I joined in as backing singers.*

Crispin Hunt
15 October 1999 London

Strange man. Had a thing for kittens.

Paul Anka
22 July 1999 New York

*I asked Paul what inspired him
to write* My Way *for Frank Sinatra.
"The Man", he answered.*

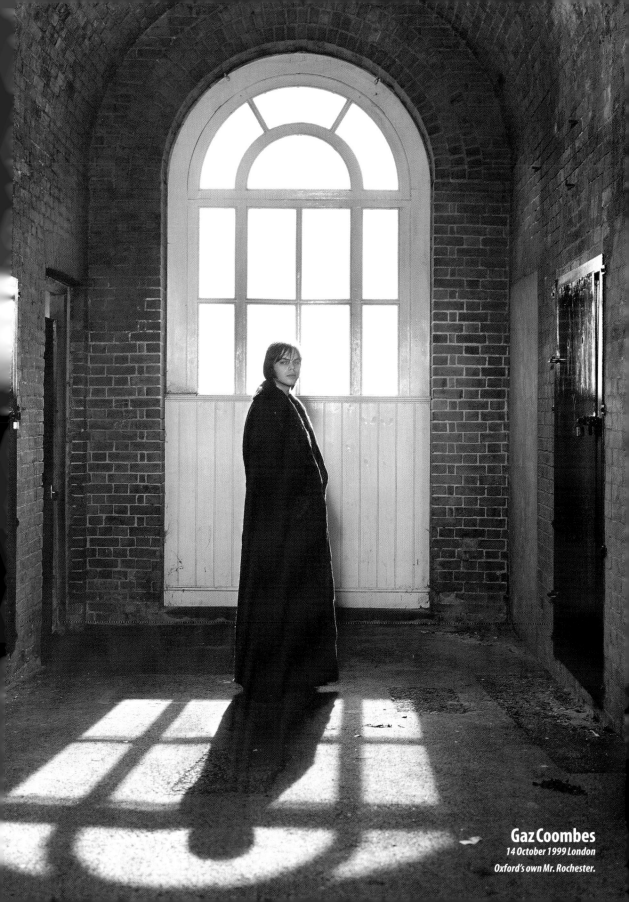

Gaz Coombes
14 October 1999 London
Oxford's own Mr. Rochester.

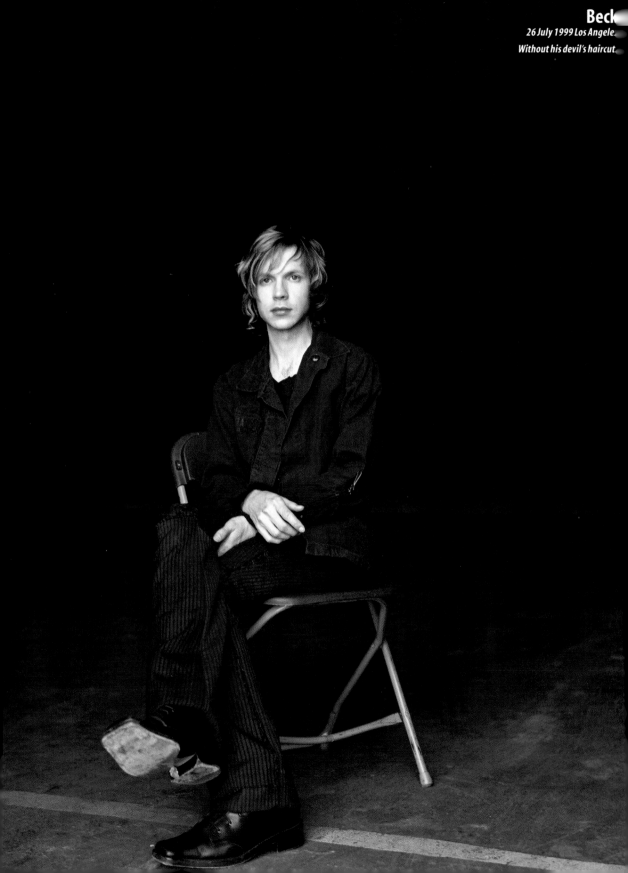

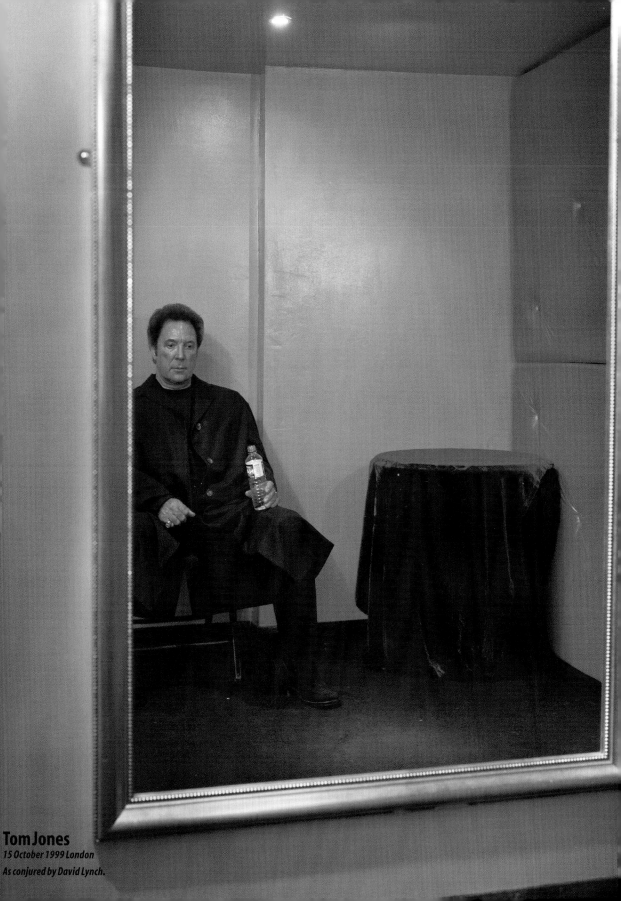

Tom Jones
15 October 1999 London
As conjured by David Lynch.

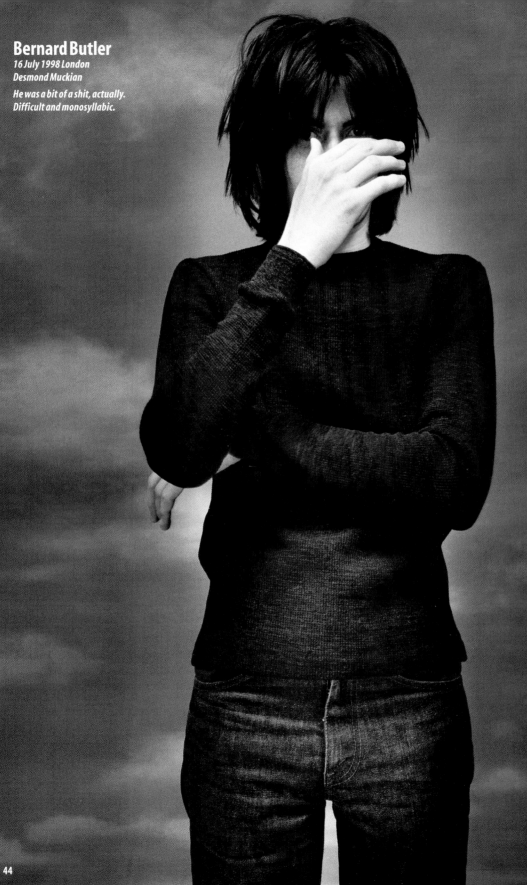

Bernard Butler
16 July 1998 London
Desmond Muckian

He was a bit of a shit, actually.
Difficult and monosyllabic.

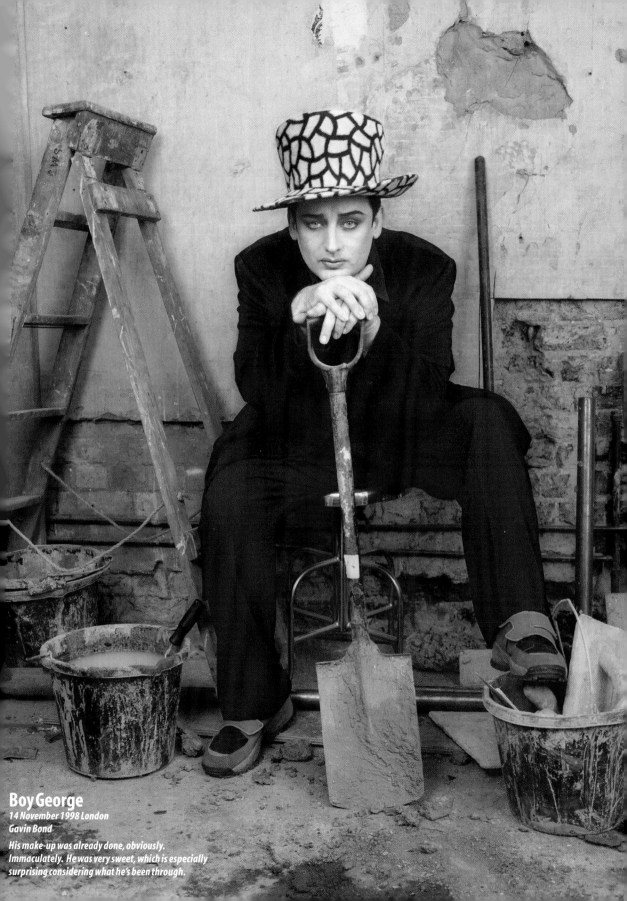

Boy George
14 November 1998 London
Gavin Bond

His make-up was already done, obviously.
Immaculately. He was very sweet, which is especially
surprising considering what he's been through.

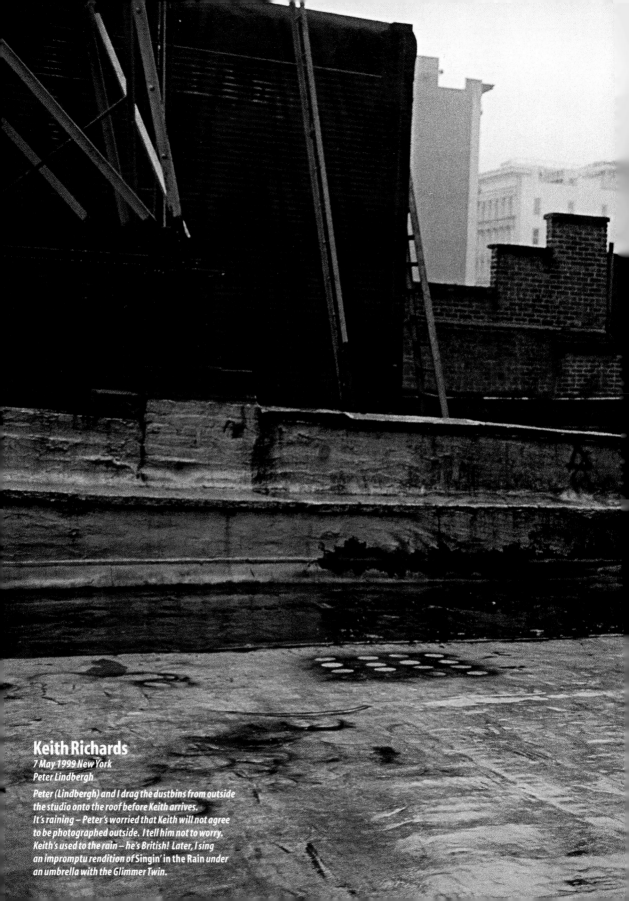

Keith Richards
7 May 1999 New York
Peter Lindbergh

*Peter (Lindbergh) and I drag the dustbins from outside
the studio onto the roof before Keith arrives.
It's raining – Peter's worried that Keith will not agree
to be photographed outside. I tell him not to worry.
Keith's used to the rain – he's British! Later, I sing
an impromptu rendition of Singin' in the Rain under
an umbrella with the Glimmer Twin.*

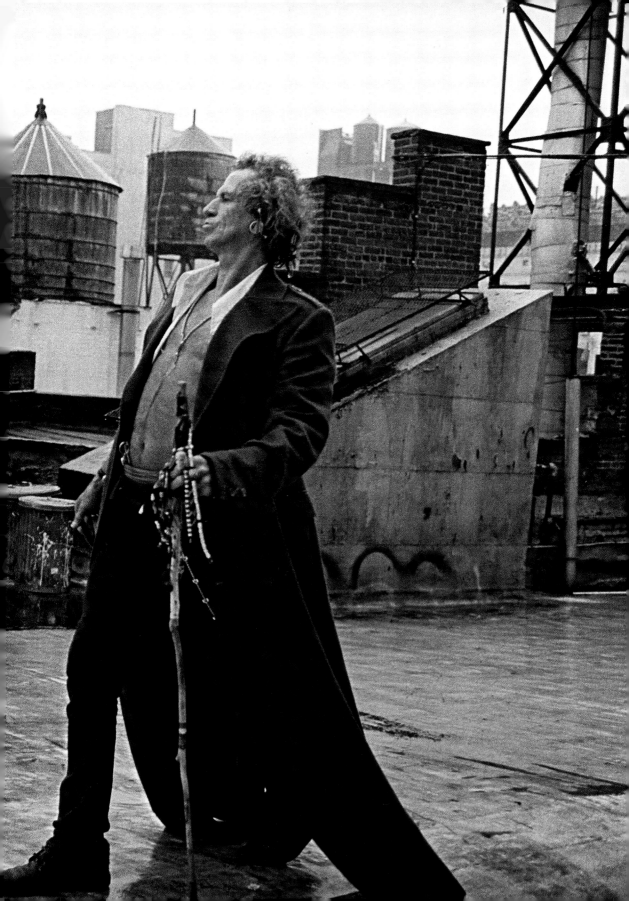

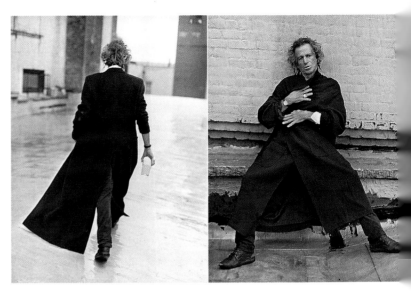

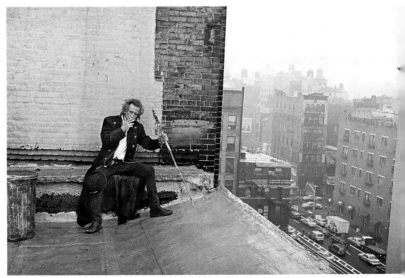

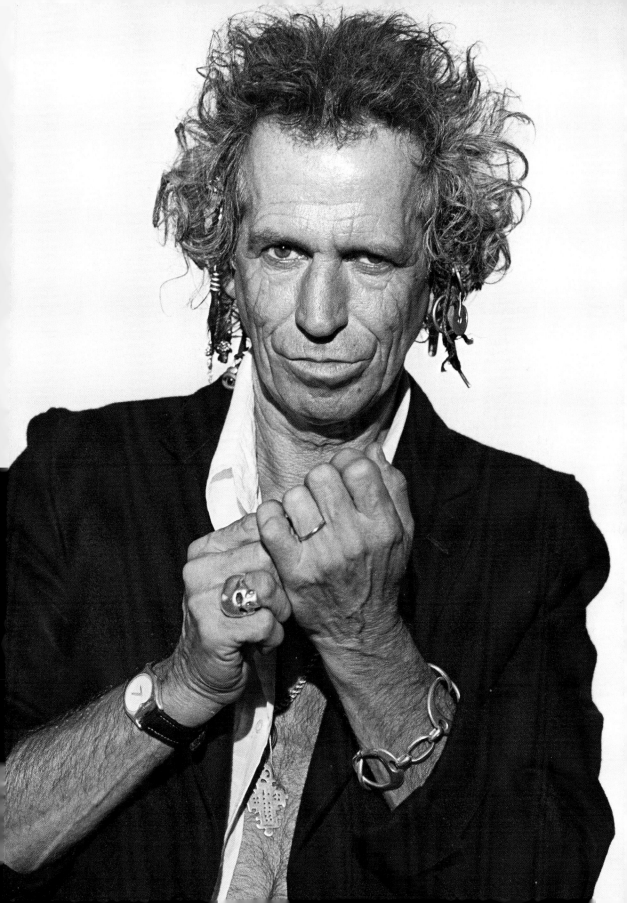

D'Angelo
2 November 1999 New York
*Stormy skies in New York. Peter (Lindbergh) and I look
out of the window. The rain is pelting down but the light
is fantastic. We decide it would be perfect to shoot
D'Angelo in the rain. He graciously complies. Once again
Peter captures a wonderful moment in the rain.*

Wyclef Jean
2 November 1999 New York

I enjoyed shooting Wyclef enormously – he spent the entire shoot rapping about moment.

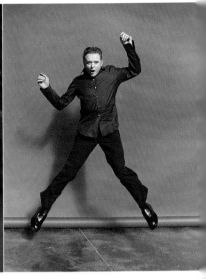

Mick Hucknall
29 September 1999 Milan

A very excitable young man, speaking Italian all over the place.

Ricky Martin
29 September 1999 Milan

Peter and I check out an old railway bridge not far from the studio. Ricky Martin and his entourage arrive with Giorgio Armani. After the photograph we walk back to the studio to be ambushed by screaming girls chanting, "Ricky, we love you! Ricky we love you! Ricky!"

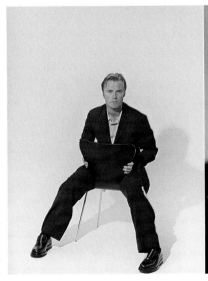

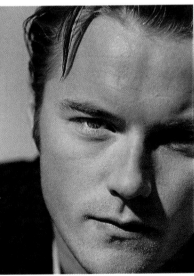

Ronan Keating
30 September 1999 London

He has his wife and baby in tow, so fantastically well behaved.

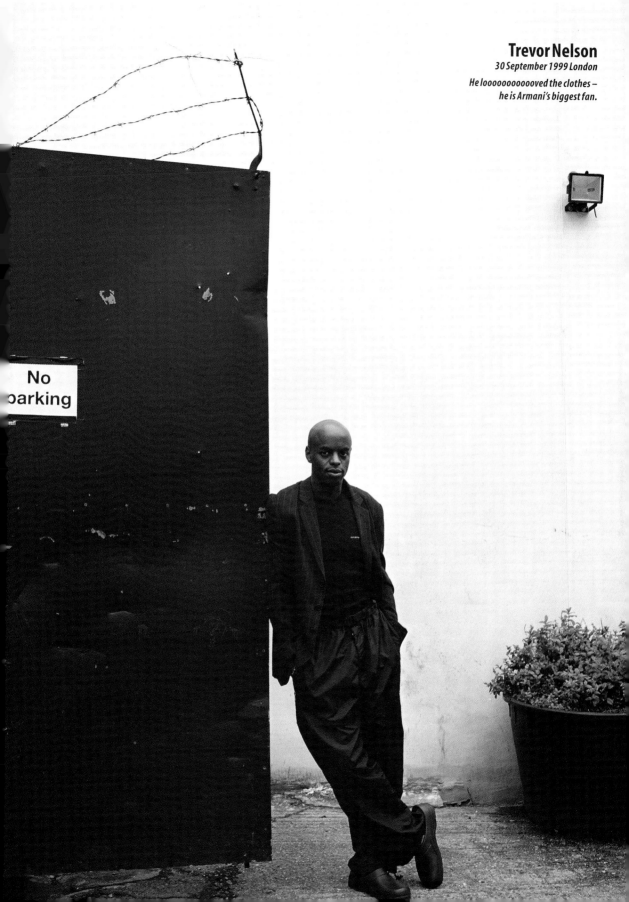

Trevor Nelson
30 September 1999 London

He loooooooooooved the clothes –
he is Armani's biggest fan.

No
parking

art

&performance

I dance therefore I am cool, I paint therefore I am stylish, I exist therefore I am... everything? The cult of peformance, be it 2D or 3D, has become somewhat hip of late, a cool distance from the iconography surrounding the artist of yore. Art today isn't just sexy, it's fantastically cool – as is the enduring confluence of art and money.

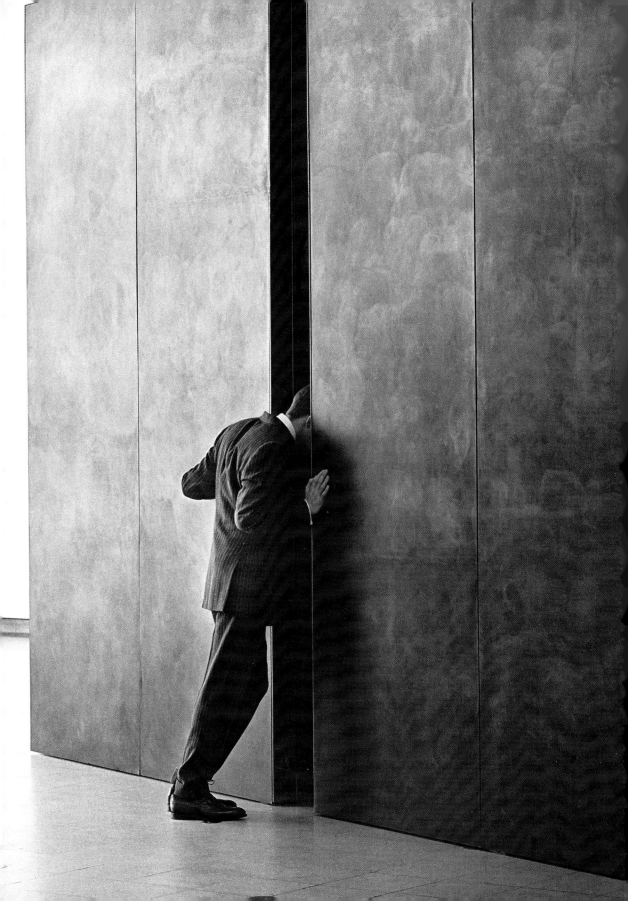

6 August 1997 London
Olivia Beesley

I arrive early at the Hayward gallery to photograph the exhibits before it opens.

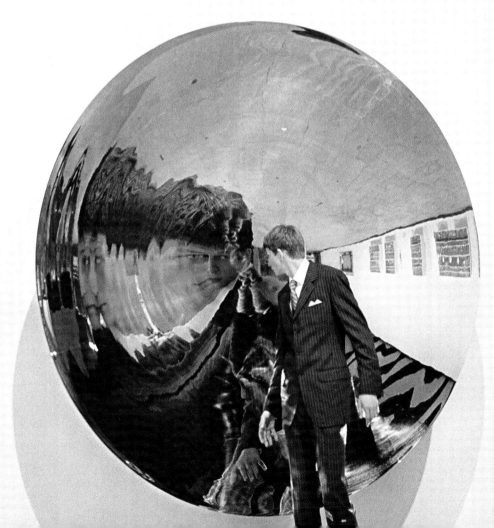

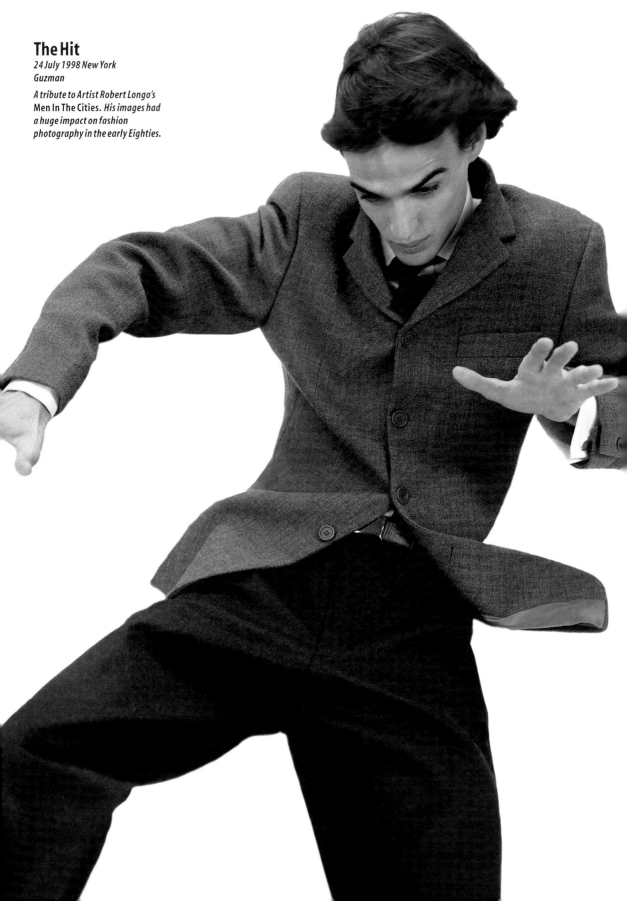

The Hit
24 July 1998 New York
Guzman

A tribute to Artist Robert Longo's **Men In The Cities.** *His images had a huge impact on fashion photography in the early Eighties.*

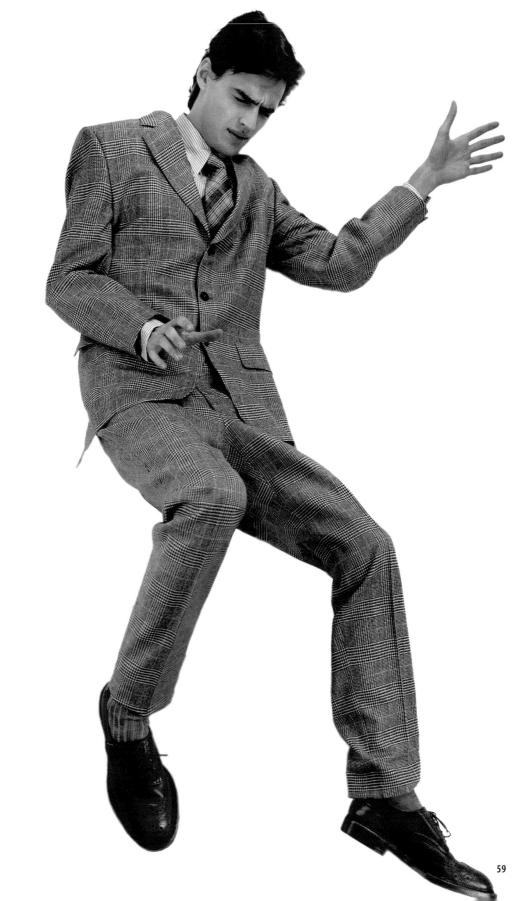

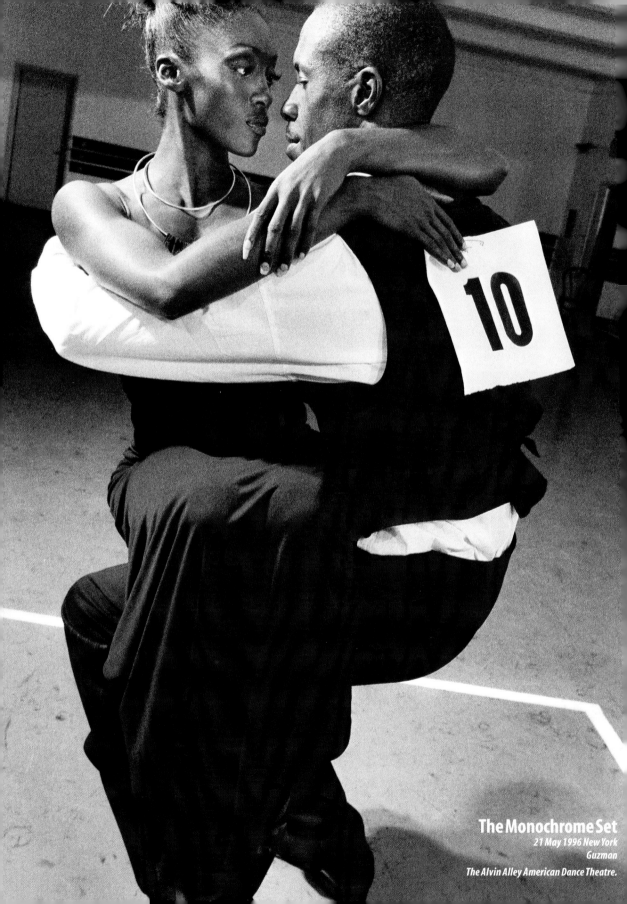

The Monochrome Set
21 May 1996 New York
Guzman
The Alvin Alley American Dance Theatre.

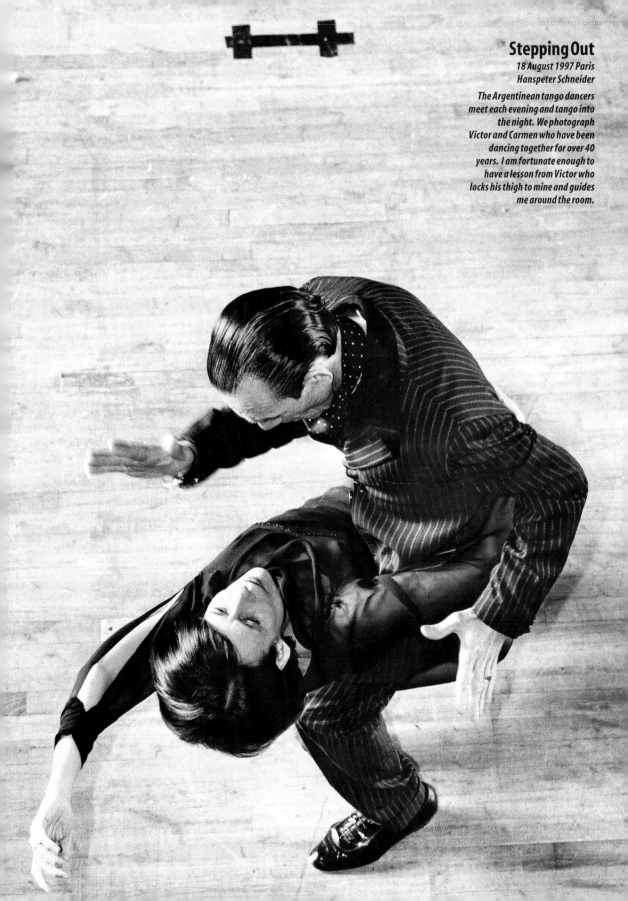

Stepping Out

18 August 1997 Paris
Hanspeter Schneider

The Argentinean tango dancers meet each evening and tango into the night. We photograph Victor and Carmen who have been dancing together for over 40 years. I am fortunate enough to have a lesson from Victor who locks his thigh to mine and guides me around the room.

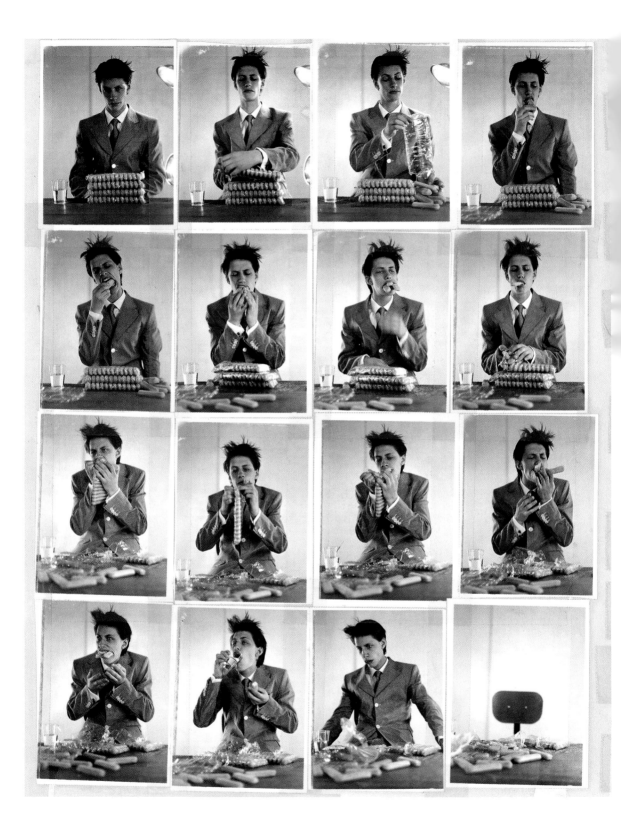

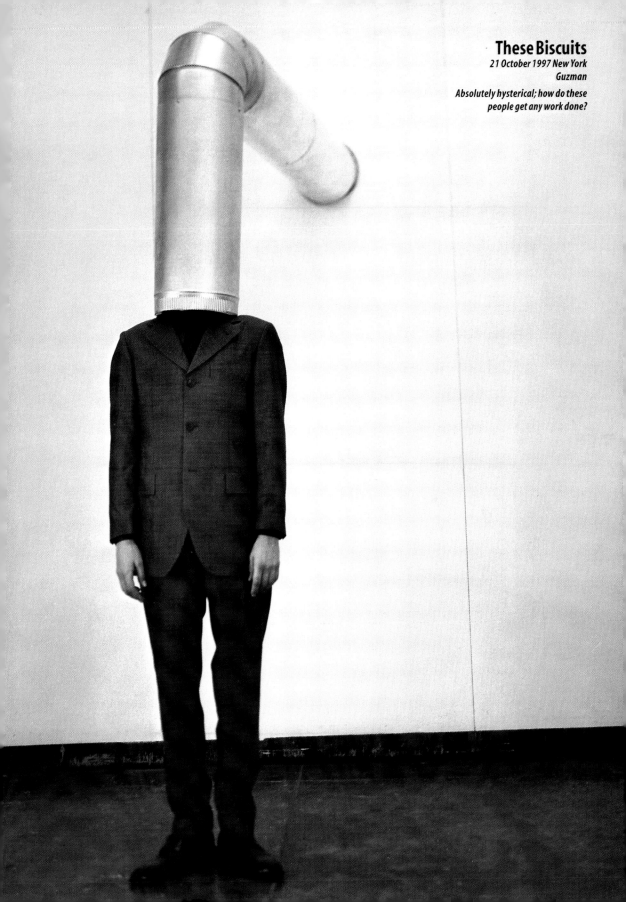

These Biscuits
21 October 1997 New York
Guzman
*Absolutely hysterical; how do these
people get any work done?*

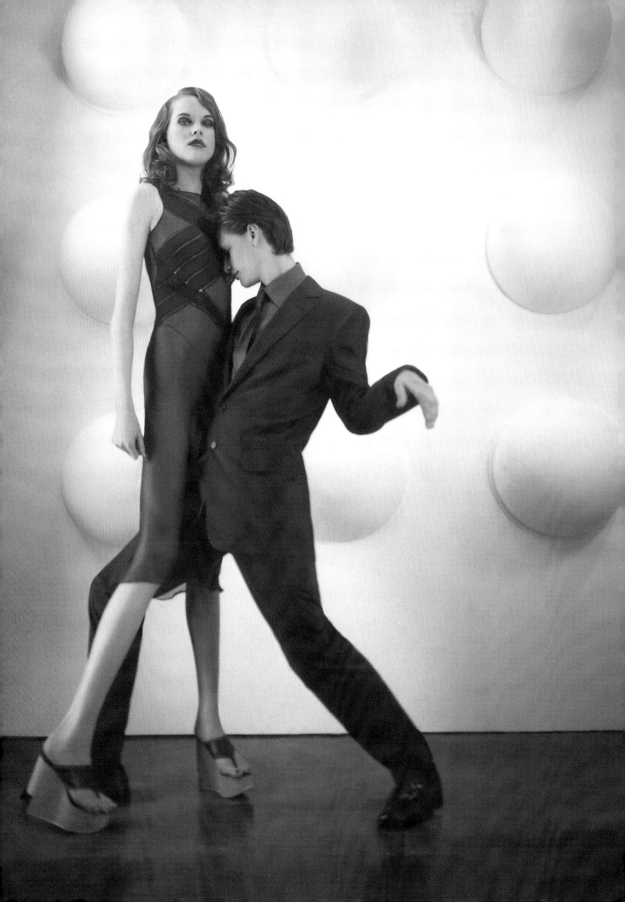

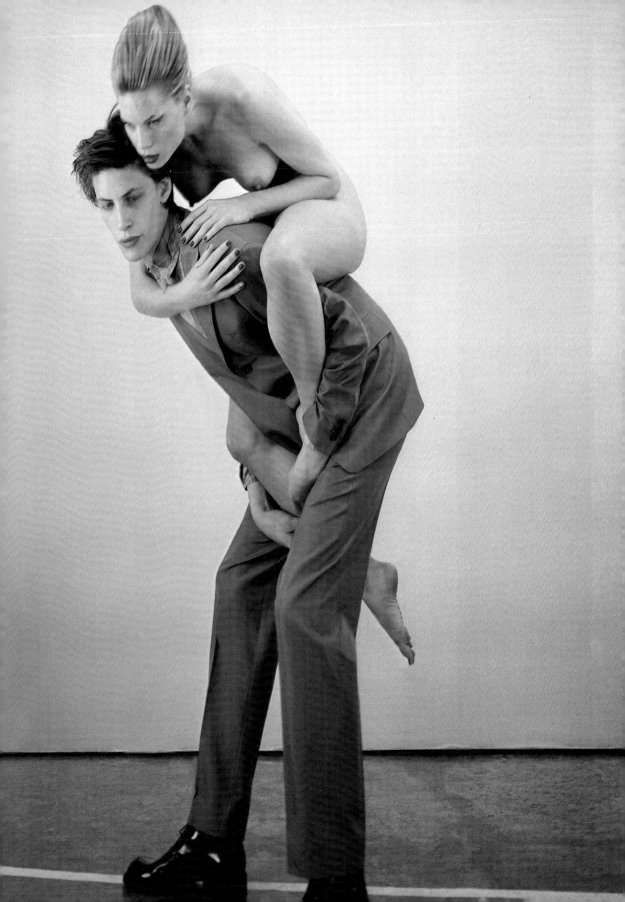

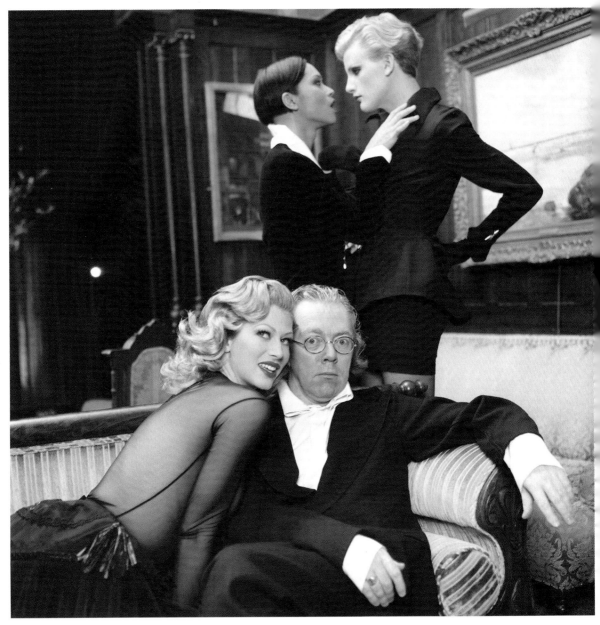

Stag Night

20 July 1994 New York
Guzman

We photograph Director Nicholas Hytner,
Designer Bob Crowley and members
of the Tony Award-winning production
of Carousel. After the performance,
the cast jump into cabs and head for the
National Arts Club at Gramercy Park
for an all-night party hosted by GQ.

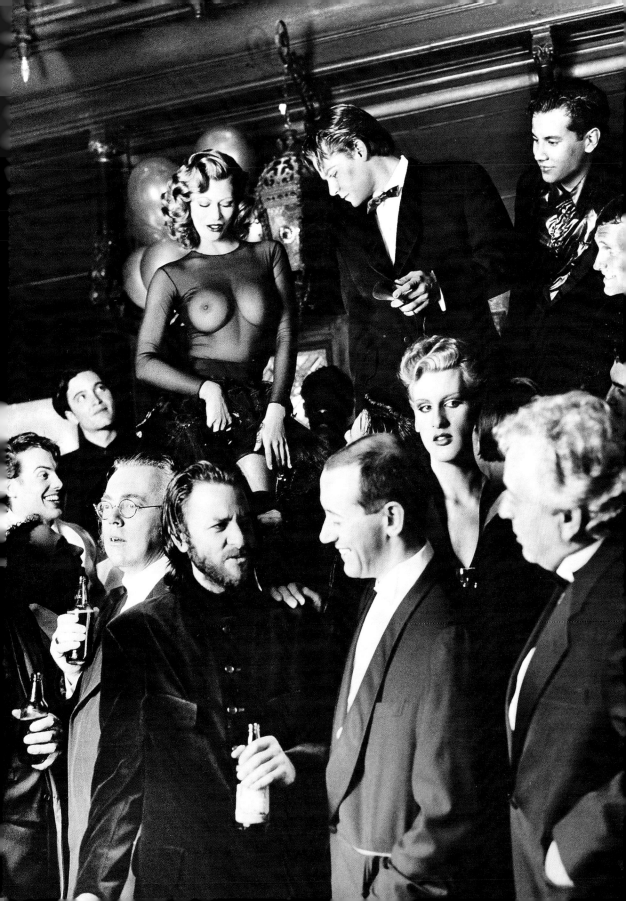

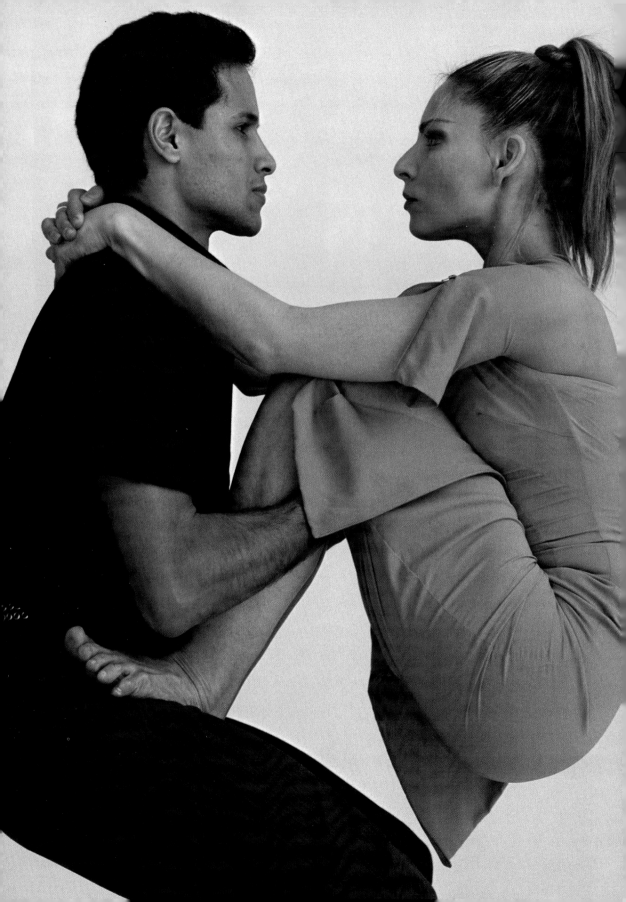

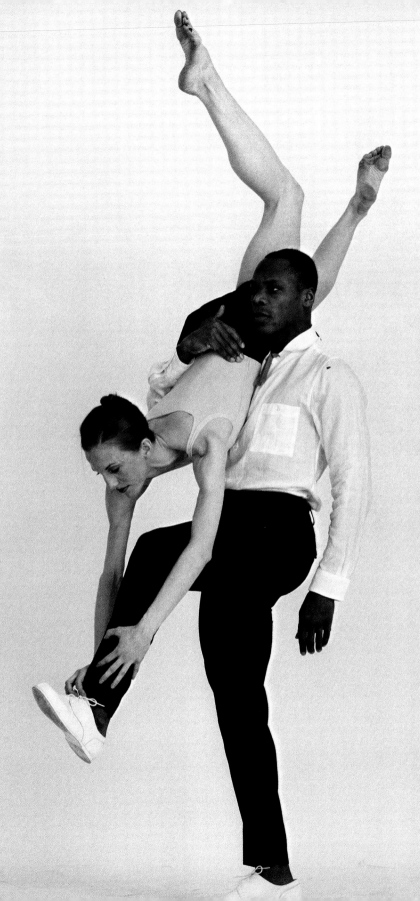

**The Return of
Don Juan**
*13 May 1999 New York
Koto Bolofo*

The New York City Ballet.

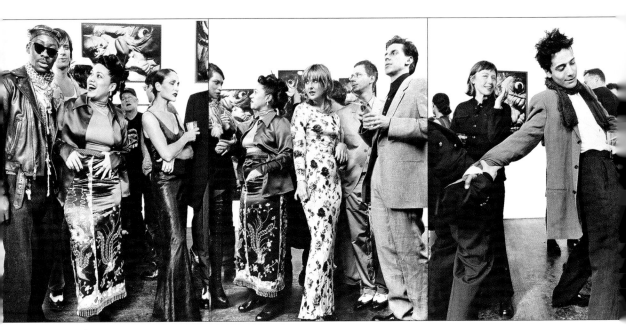

Private View
4 February 1995 New York
Guzman

Cindy Sherman private view.
Guests include Quentin Crisp and Taylor Mead.

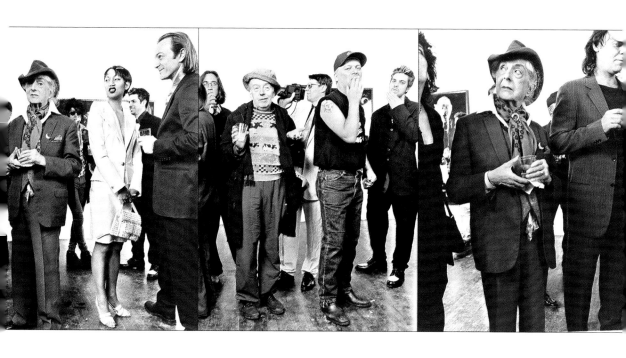

actors

01

Actors were always cool, always studied and clipped, always wary of themselves, so using style and demeanor as an armour has been an essential strand of their work. Consequently it has never been more difficult for members of the acting profession to project their innate sense of style. Which is probably why they are still the coolest people on earth...

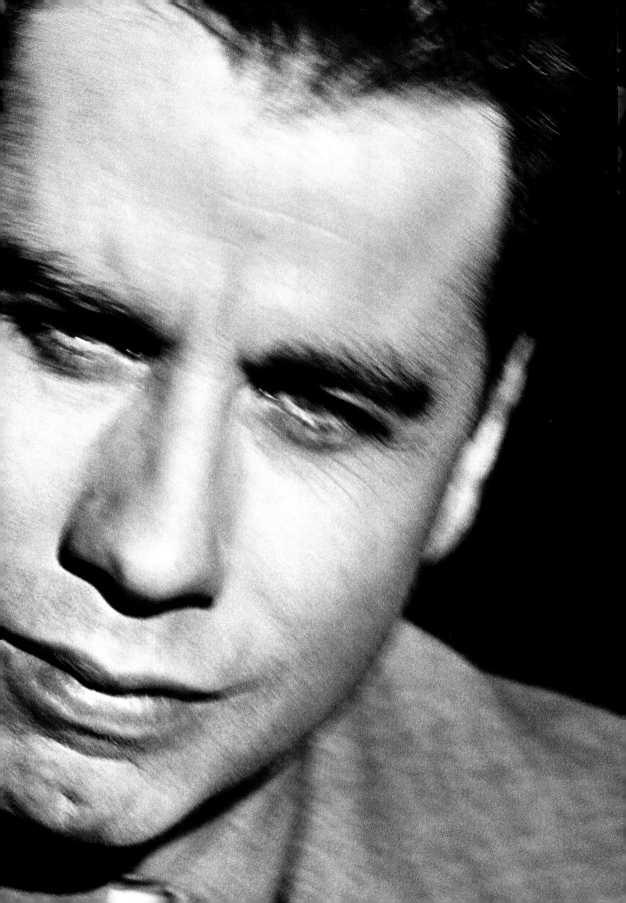

This was shot at Smashbox Studios in L.A. I chatted to John about Pulp Fiction – especially the moment when he dances with Uma Thurman. He proceeded to take off his shoes and danced again for us. A rapport was struck up between Peter and John, who reminded me of two dancing bears.

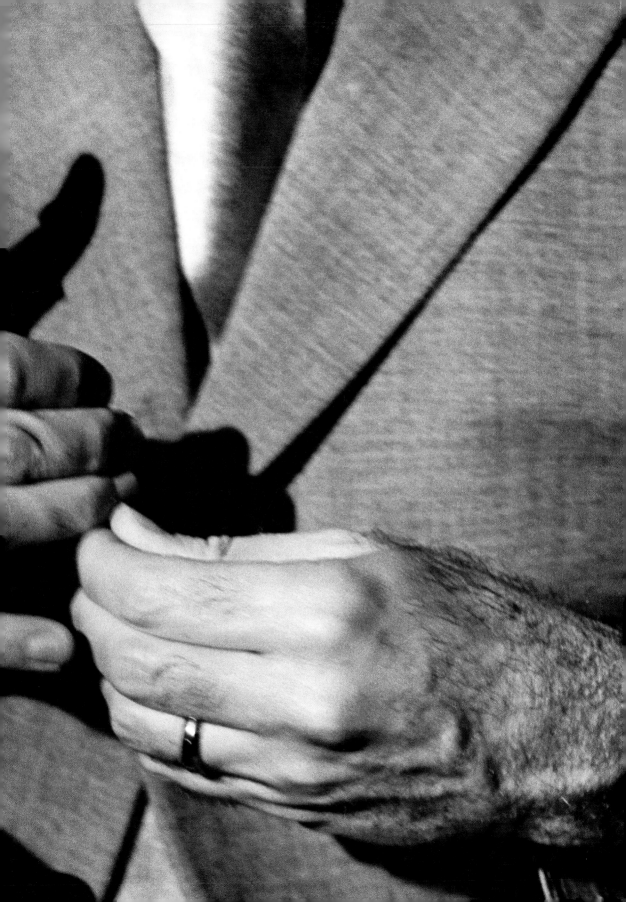

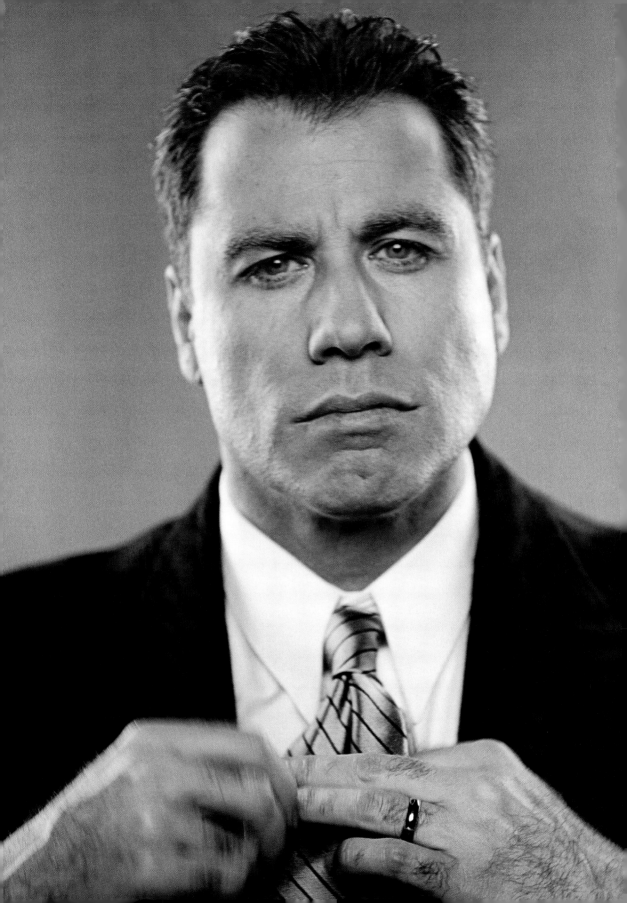

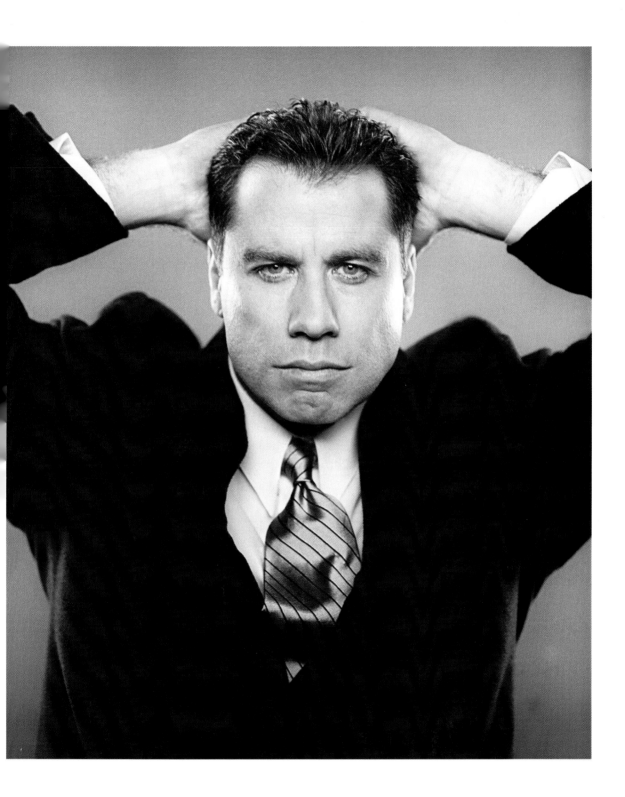

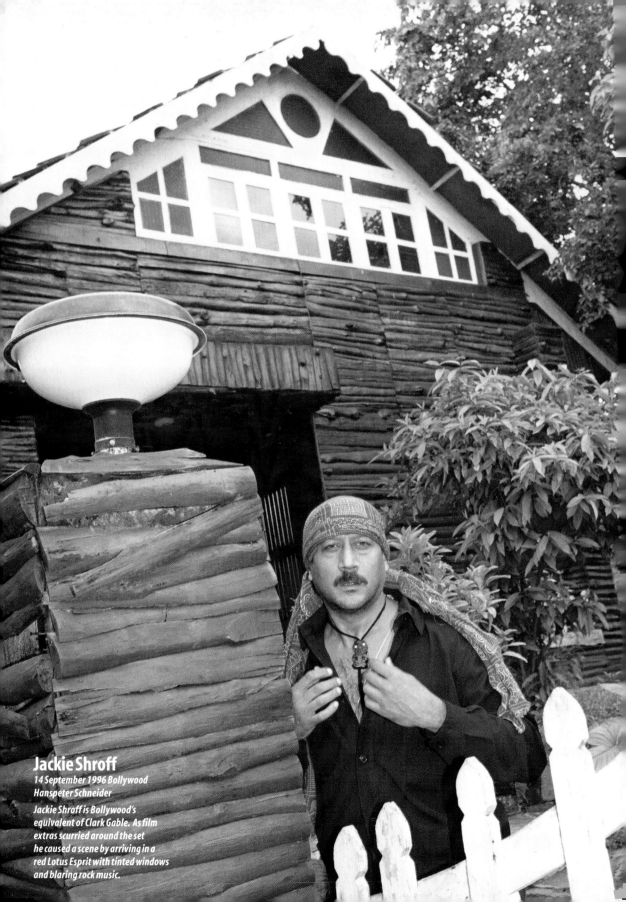

Jackie Shroff

14 September 1996 Bollywood
Hanspeter Schneider

Jackie Shroff is Bollywood's
equivalent of Clark Gable. As film
extras scurried around the set
he caused a scene by arriving in a
red Lotus Esprit with tinted windows
and blaring rock music.

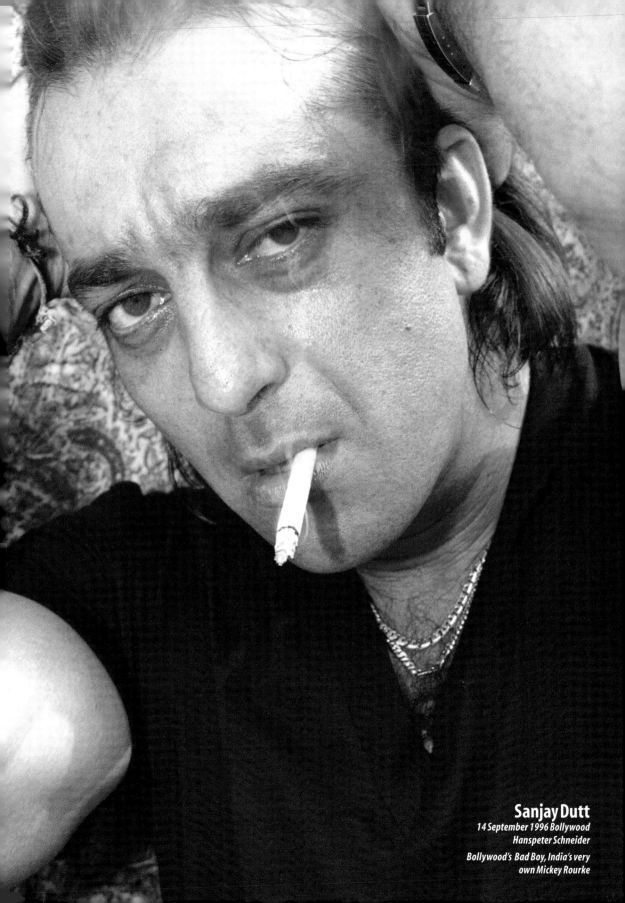

Sanjay Dutt
*14 September 1996 Bollywood
Hanspeter Schneider*

*Bollywood's Bad Boy, India's very
own Mickey Rourke*

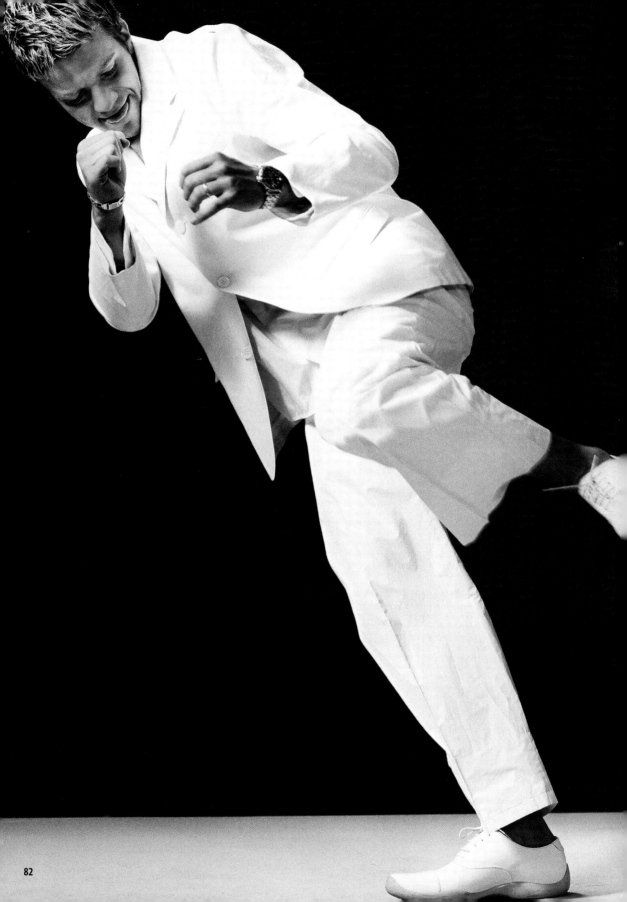

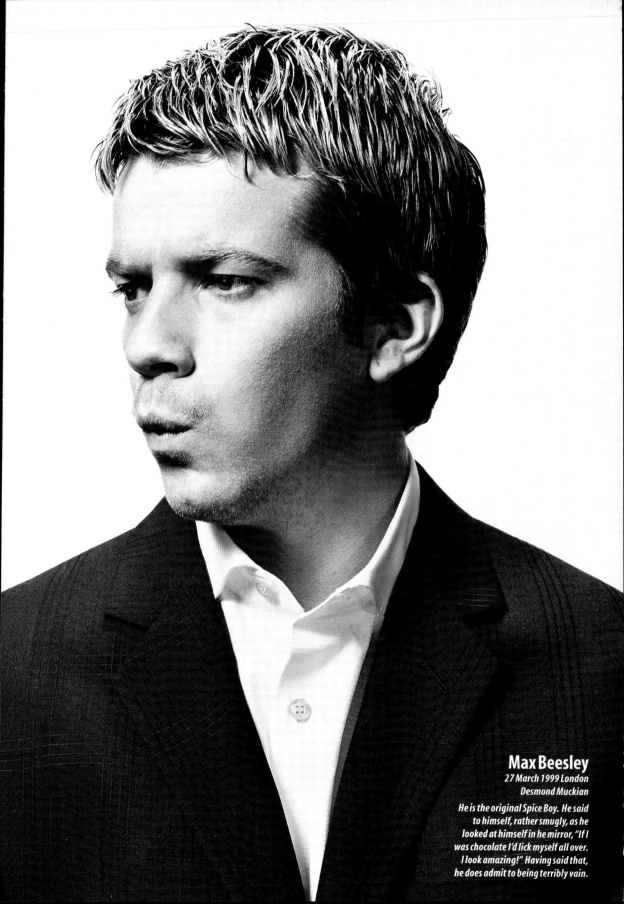

Max Beesley
27 March 1999 London
Desmond Muckian

He is the original Spice Boy. He said
to himself, rather smugly, as he
looked at himself in he mirror, "If I
was chocolate I'd lick myself all over.
I look amazing!" Having said that,
he does admit to being terribly vain.

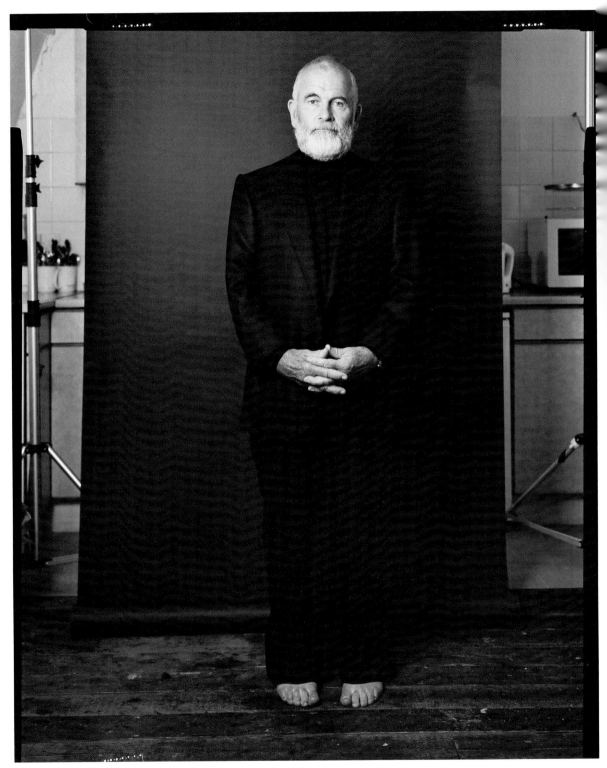

Ian Holm
28 May 1997 London
Jillian Edelstein

Holm is something of a hero of mine, one of the old school,
and one of our very, very best actors.

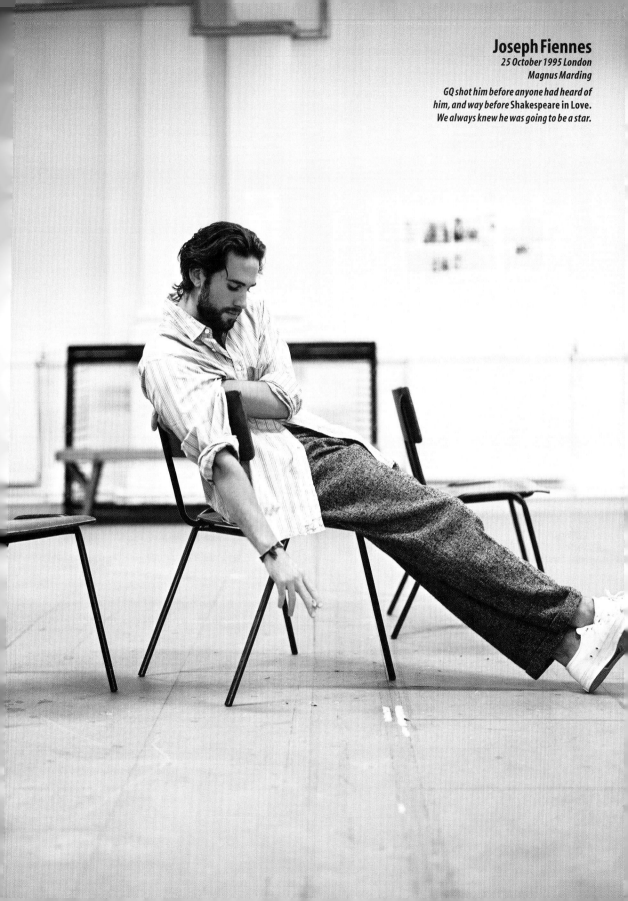

Joseph Fiennes
25 October 1995 London
Magnus Marding

*GQ shot him before anyone had heard of
him, and way before Shakespeare in Love.
We always knew he was going to be a star.*

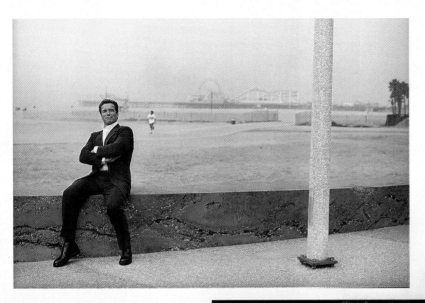

Lawrence Fishburne

2 November 1999 New York

Don't call him Larry!
Funny, articulate, larger than life.
I'd forgotten he was only 14 when he
starred in Francis Ford Coppola's 1979
Cambodia trip, Apocalypse Now,
though it all came back when we met.
He still had that amazing intensity.

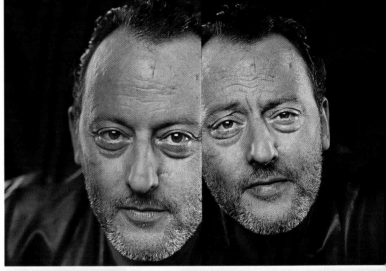

Jean Reno

29 September 1999 Milan

The strangest thing about France's
most mesmerising actor is that
he's really not French at all. Born to
Spanish parents in Casablanca in 1948,
he moved to France when he was
seventeen. He was soooooo000 amazing
to photograph. He was a great man,
a cool man, and a very easy man to get
on with. A GQ man.

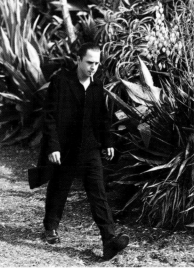

Giovanni Ribisi

5 November 1999 Los Angeles

Phoebe's younger brother,
a Prince among men.

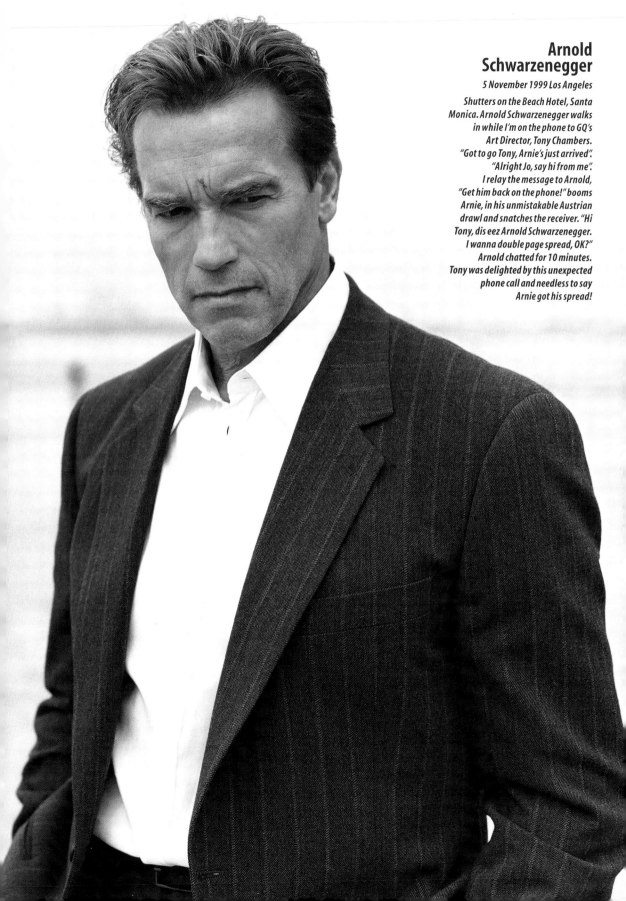

Arnold Schwarzenegger

5 November 1999 Los Angeles

Shutters on the Beach Hotel, Santa Monica. Arnold Schwarzenegger walks in while I'm on the phone to GQ's Art Director, Tony Chambers. "Got to go Tony, Arnie's just arrived". "Alright Jo, say hi from me". I relay the message to Arnold, "Get him back on the phone!" booms Arnie, in his unmistakable Austrian drawl and snatches the receiver. "Hi Tony, dis eez Arnold Schwarzenegger. I wanna double page spread, OK?" Arnold chatted for 10 minutes. Tony was delighted by this unexpected phone call and needless to say Arnie got his spread!

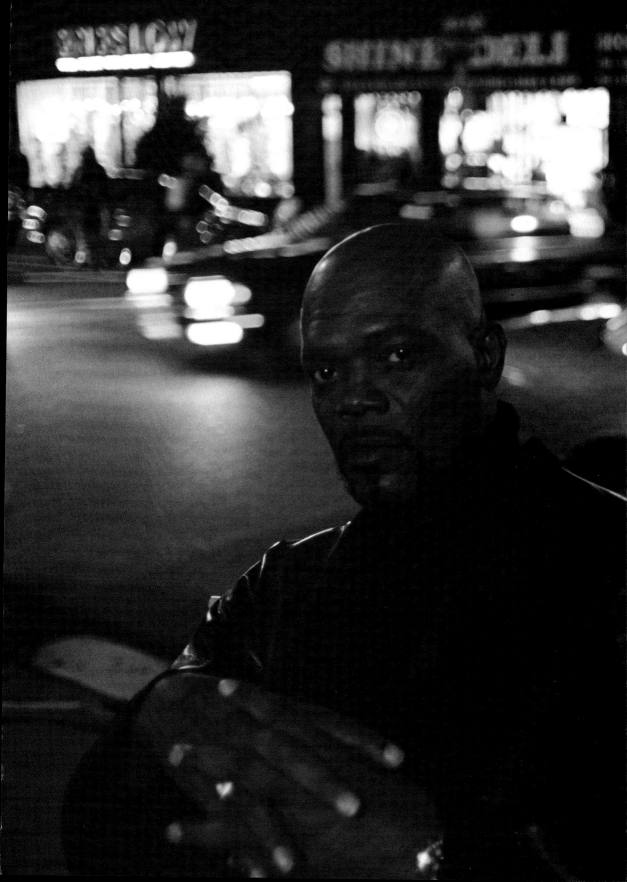

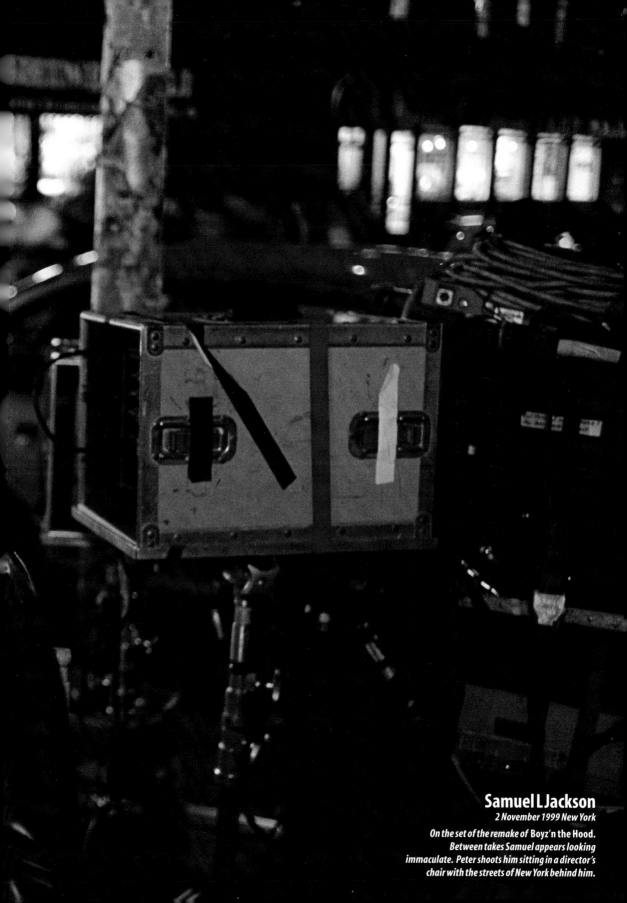

Samuel L Jackson
2 November 1999 New York

On the set of the remake of Boyz'n the Hood.
Between takes Samuel appears looking
immaculate. Peter shoots him sitting in a director's
chair with the streets of New York behind him.

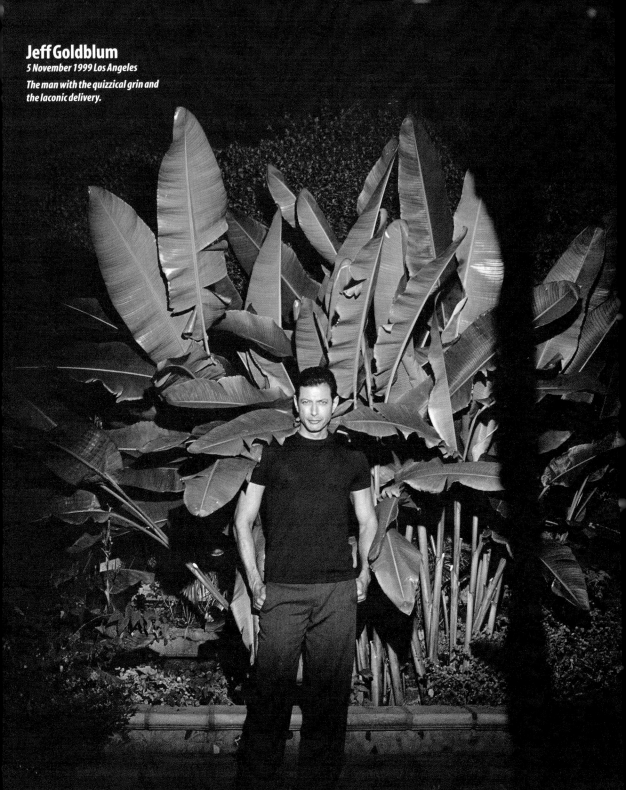

Jeff Goldblum

5 November 1999 Los Angeles

The man with the quizzical grin and the laconic delivery.

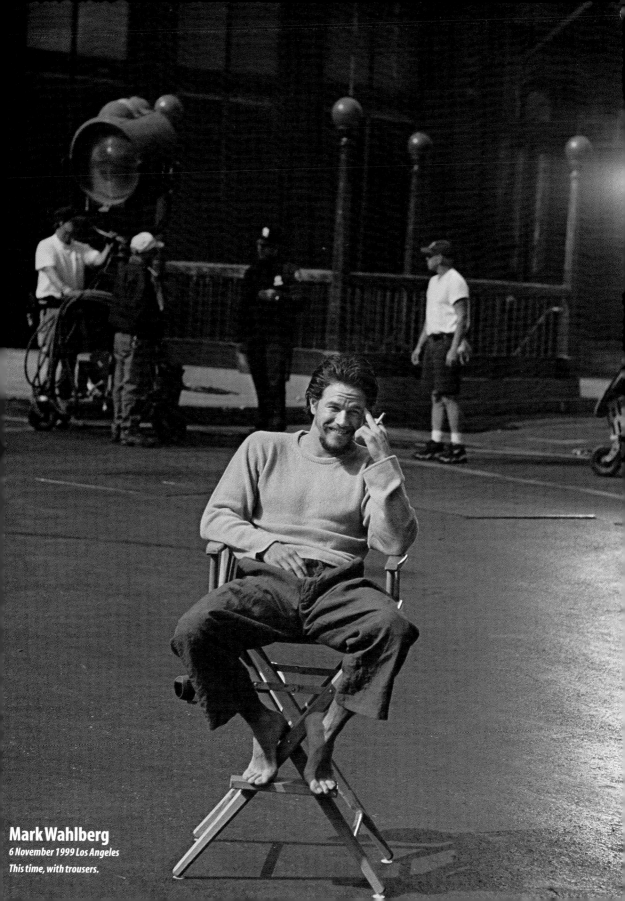

Mark Wahlberg
6 November 1999 Los Angeles
This time, with trousers.

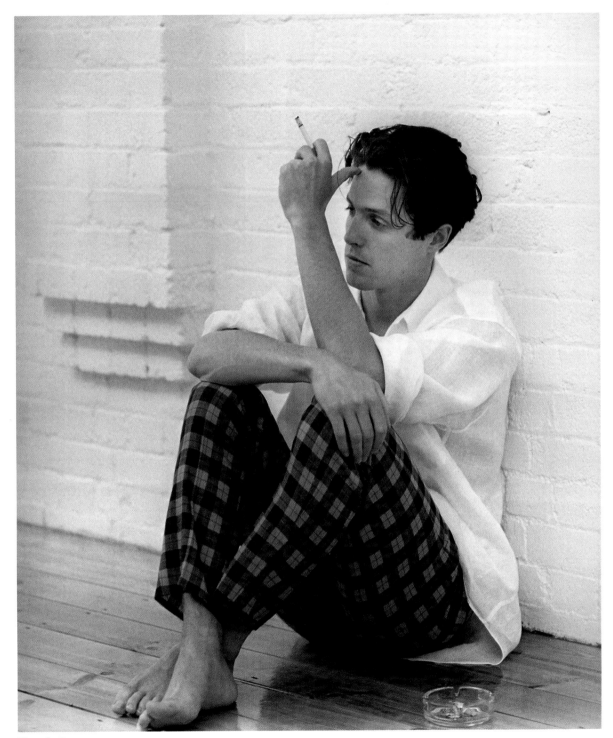

Hugh Grant
1 March 1994 London
David Eustace

*Standing in front of the camera, Hugh looks petrified; this
is his first publicity shoot for Four Weddings And A Funeral.
As he munches nervously on a Kit-Kat he starts flicking
that famous floppy fringe. "OK," I laugh, "Do you want a curby
grip or an Alice band?" This immediately breaks the ice.*

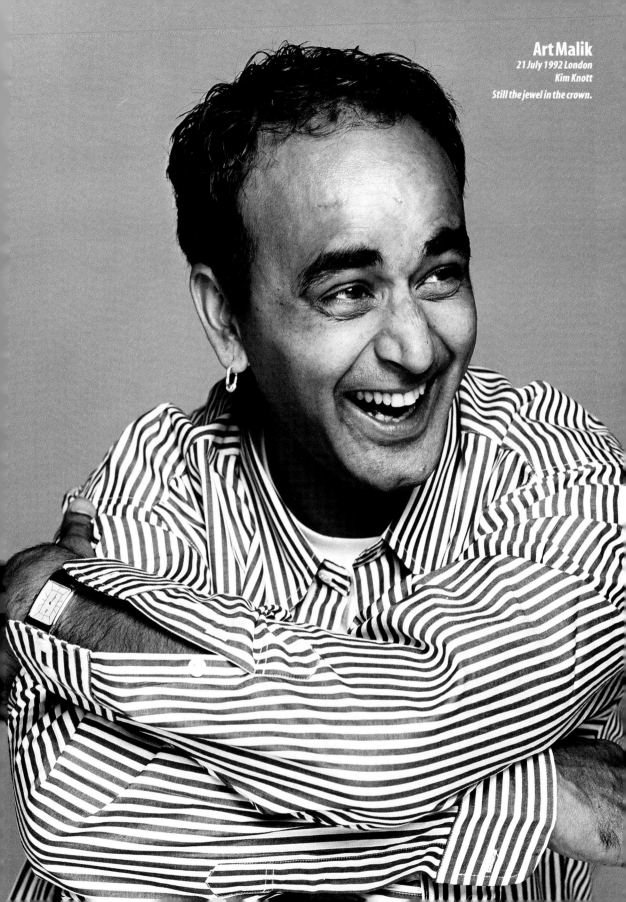

Art Malik
21 July 1992 London
Kim Knott
Still the jewel in the crown.

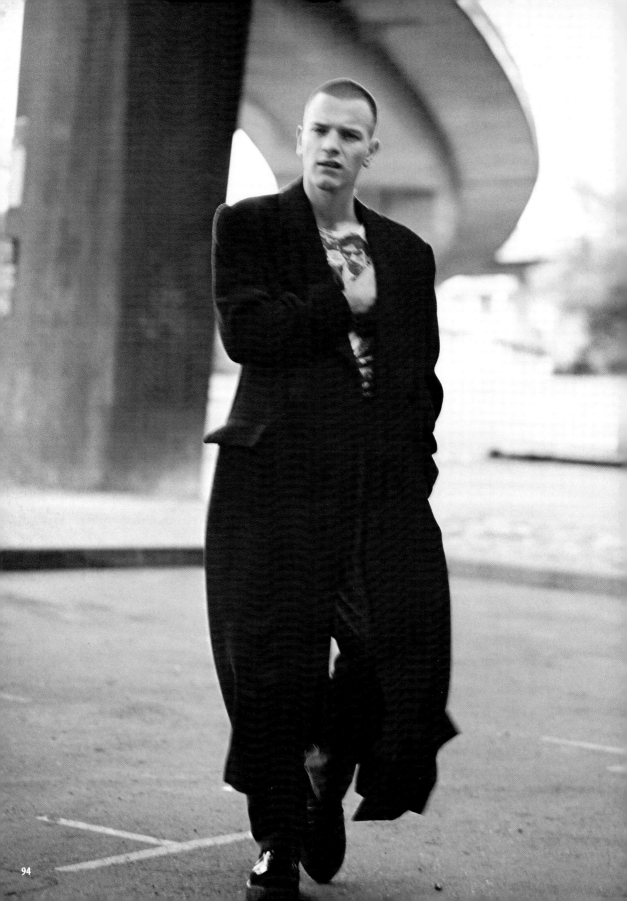

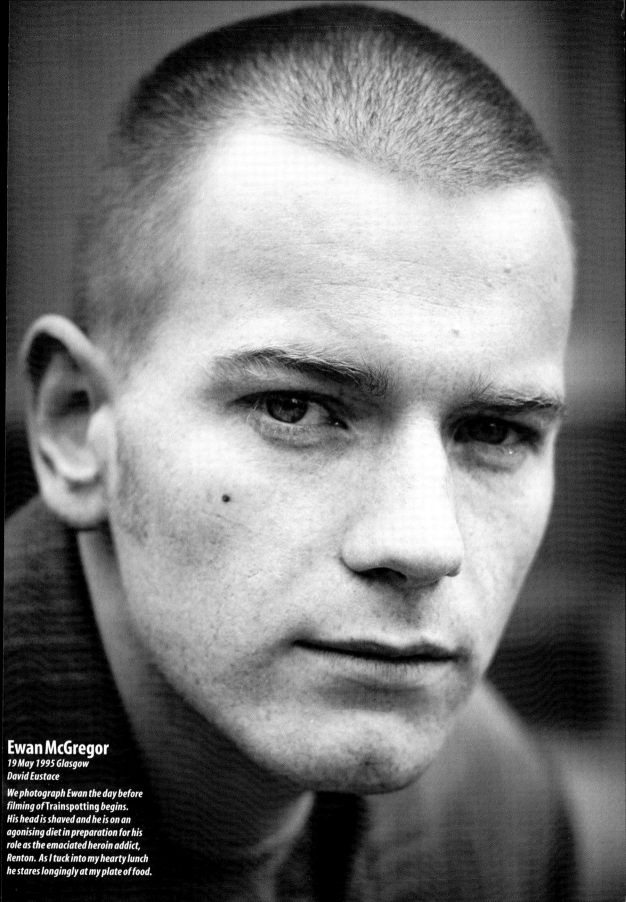

Ewan McGregor
19 May 1995 Glasgow
David Eustace

We photograph Ewan the day before filming of Trainspotting begins. His head is shaved and he is on an agonising diet in preparation for his role as the emaciated heroin addict, Renton. As I tuck into my hearty lunch he stares longingly at my plate of food.

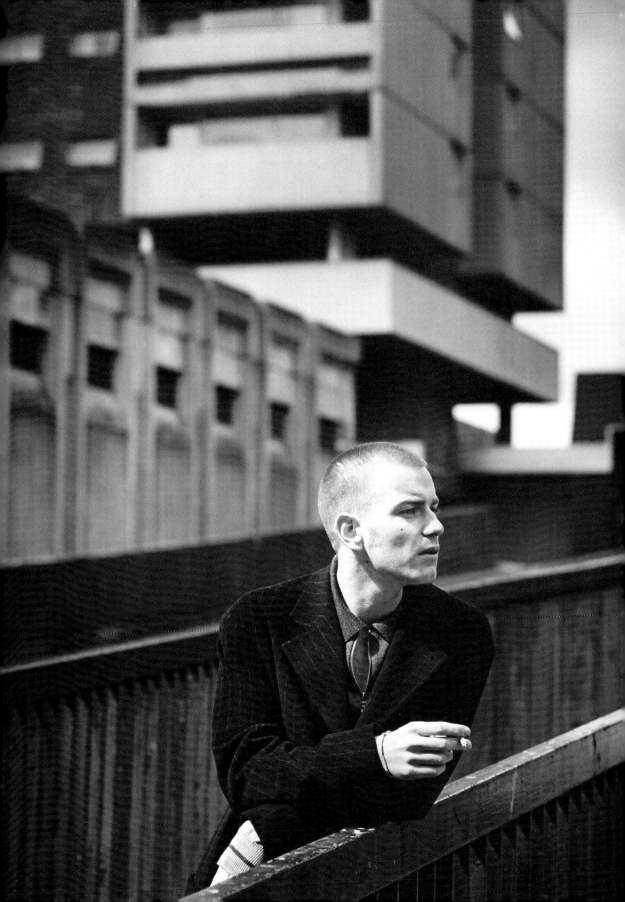

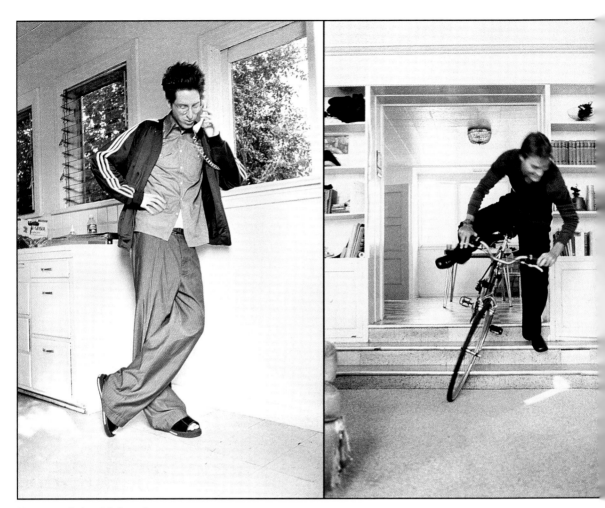

House of the Rising Sons

9 October 1997 Los Angeles
Laura Wilson

This assignment was nerve-racking for Laura who slips out of the role of mother and into the role of photographer. Her sons' house is ordered chaos – completely boys' own. Luke, Owen and Andrew, and their friend Wes Anderson tease her mercilessly.

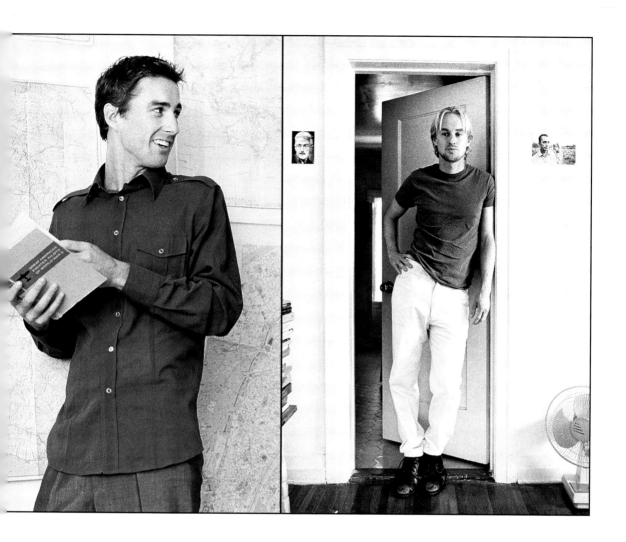

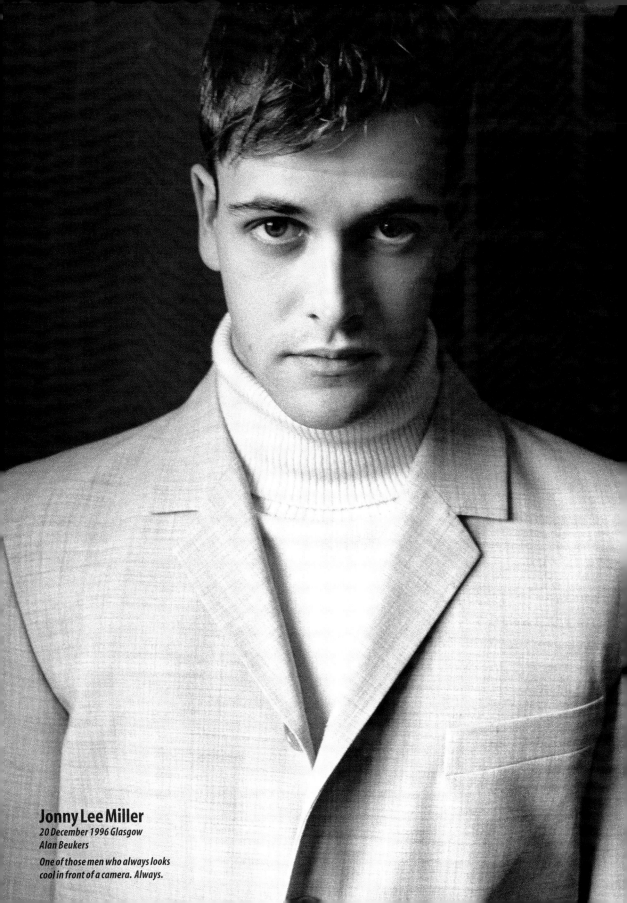

Jonny Lee Miller
20 December 1996 Glasgow
Alan Beukers

One of those men who always looks
cool in front of a camera. Always.

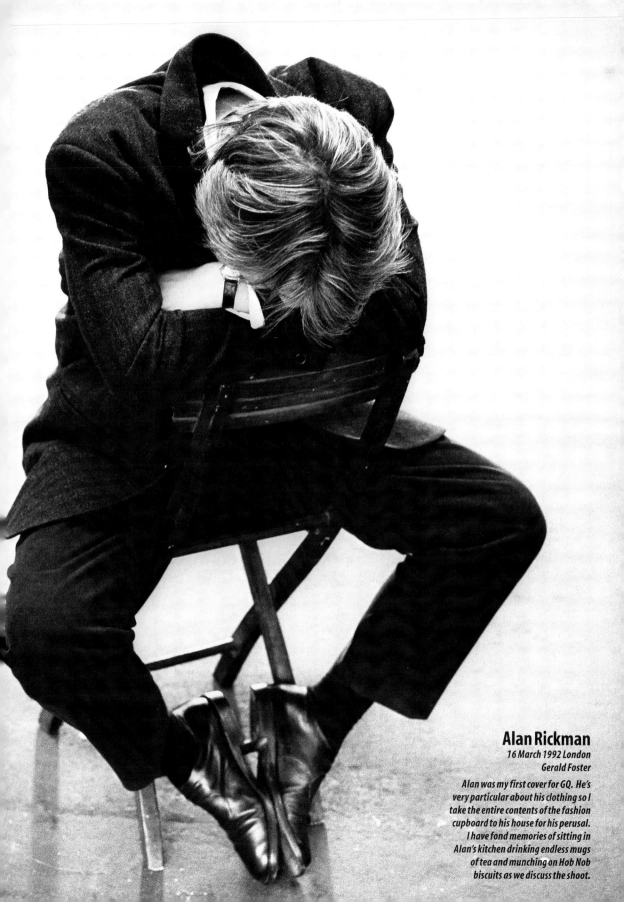

Alan Rickman
16 March 1992 London
Gerald Foster

*Alan was my first cover for GQ. He's
very particular about his clothing so I
take the entire contents of the fashion
cupboard to his house for his perusal.
I have fond memories of sitting in
Alan's kitchen drinking endless mugs
of tea and munching on Hob Nob
biscuits as we discuss the shoot.*

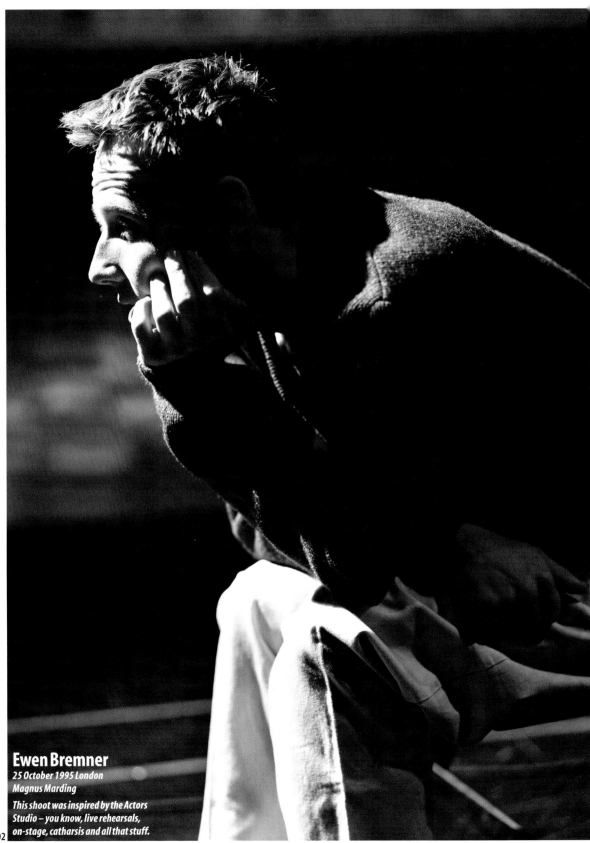

Ewen Bremner
25 October 1995 London
Magnus Marding

This shoot was inspired by the Actors Studio – you know, live rehearsals, on-stage, catharsis and all that stuff.

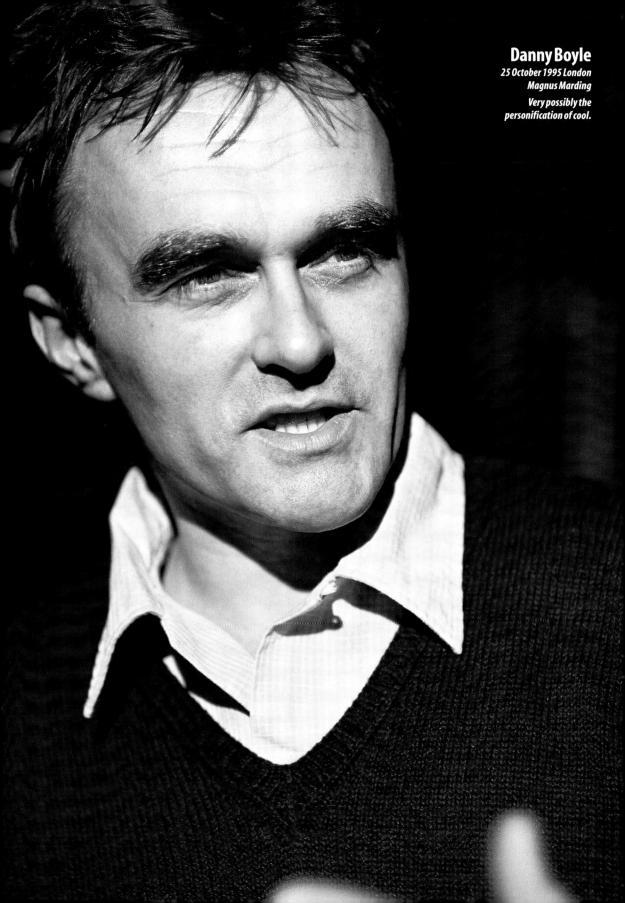

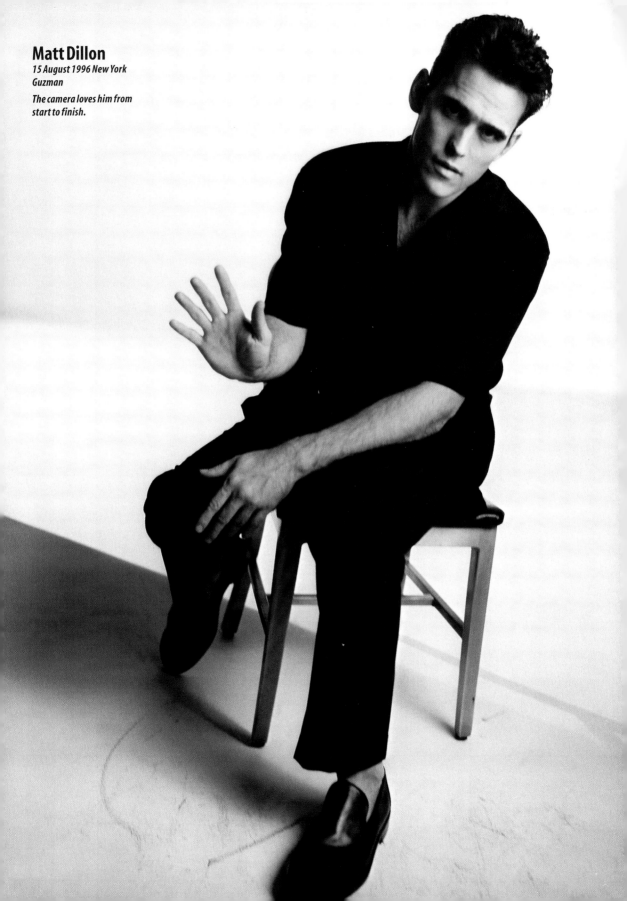

Matt Dillon
*15 August 1996 New York
Guzman*

*The camera loves him from
start to finish.*

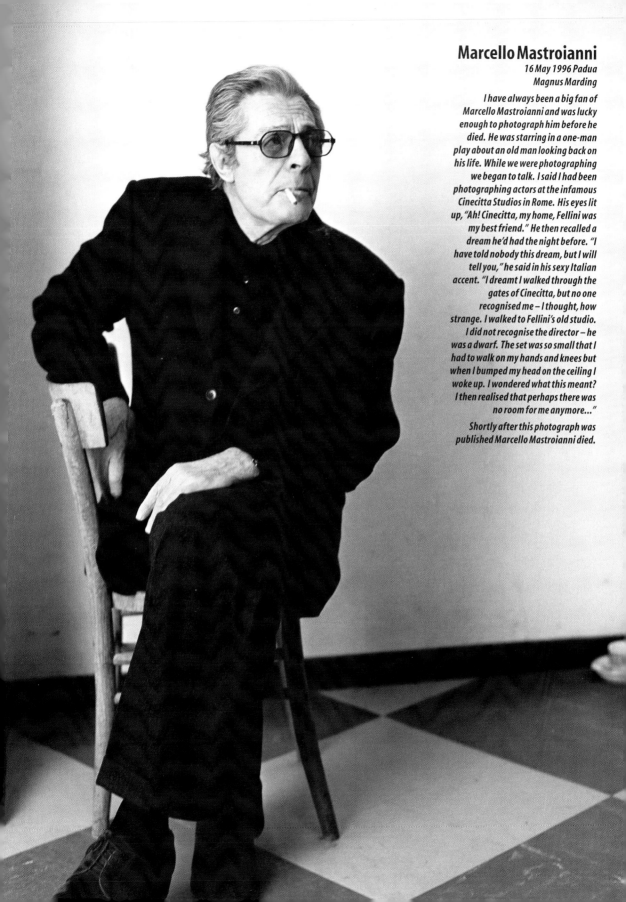

Marcello Mastroianni

16 May 1996 Padua
Magnus Marding

I have always been a big fan of Marcello Mastroianni and was lucky enough to photograph him before he died. He was starring in a one-man play about an old man looking back on his life. While we were photographing we began to talk. I said I had been photographing actors at the infamous Cinecitta Studios in Rome. His eyes lit up, "Ah! Cinecitta, my home, Fellini was my best friend." He then recalled a dream he'd had the night before. "I have told nobody this dream, but I will tell you," he said in his sexy Italian accent. "I dreamt I walked through the gates of Cinecitta, but no one recognised me – I thought, how strange. I walked to Fellini's old studio. I did not recognise the director – he was a dwarf. The set was so small that I had to walk on my hands and knees but when I bumped my head on the ceiling I woke up. I wondered what this meant? I then realised that perhaps there was no room for me anymore..."

Shortly after this photograph was published Marcello Mastroianni died.

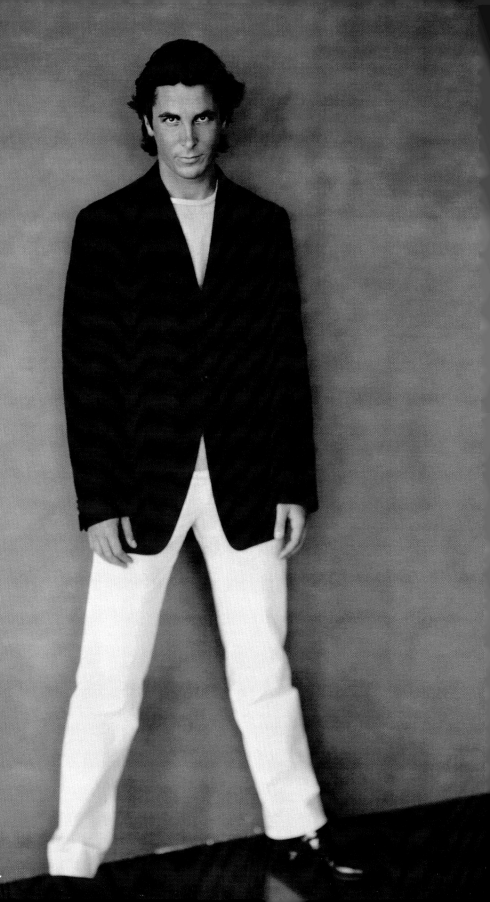

Christian Bale
*16 May 1999 Los Angeles
American Psycho to the max.*

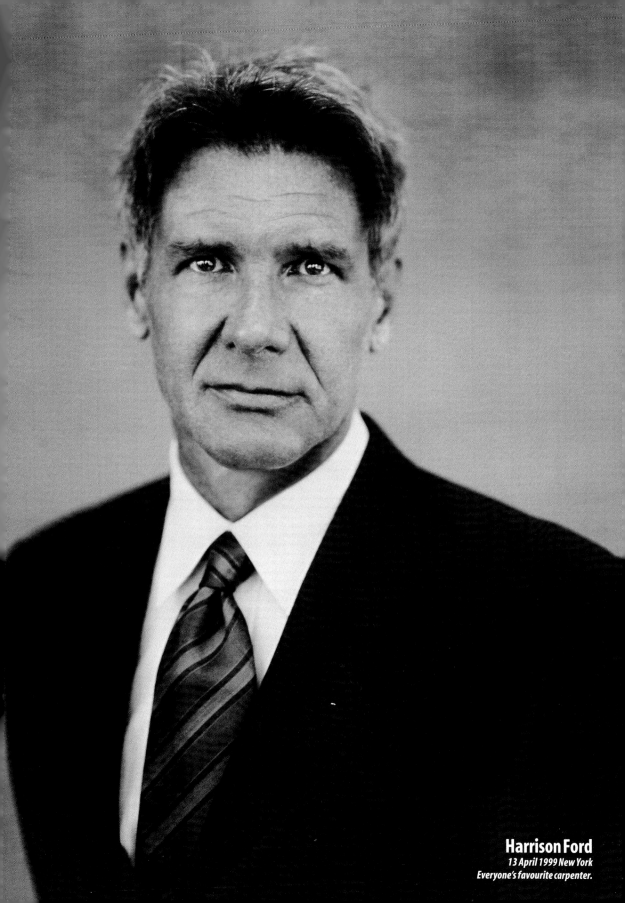

Harrison Ford
13 April 1999 New York
Everyone's favourite carpenter.

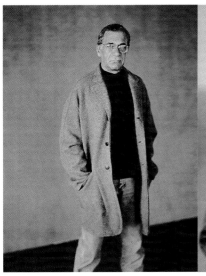

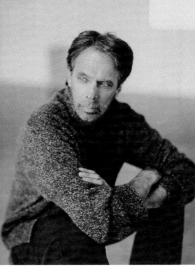

Sidney Pollack
16 May 1999 Los Angeles

Director, actor, GQ man.

Jerry Bruckheimer
15 May 1999 Los Angeles

Infamous in cashmere.

John Carpenter
15 May 1999 Los Angeles

Silk thriller

Roman Polanski
11 May 1999 Paris

The naughty boy in linen.

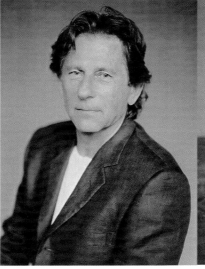

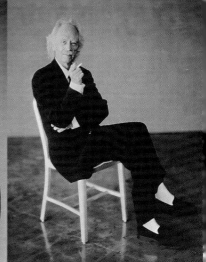

Billy Zane
15 May 1999 Smashbox Studio LA

While shooting Billy Zane, Danny DeVito turns up. He glances over and sees Paolo's huge plate camera on a giant tripod. "Is that camera real?" he asks. Paolo gets down from his box to allow Danny to peek through the lens. He can't reach. Paolo finds a second box to put on the first one. Danny now can't step up onto the second box as it's too high. Paolo quickly finds a third box to put in front of the first box, so he can step up, and up again. Finally he gets a peek – a real Laurel and Hardy moment!

Peter Beard
April 13, 1999 New York

Peter Beard strolls in after a night of partying. Paolo takes his portrait. Peter then curls up on the sofa and falls asleep, oblivious to the continual stream of personalities passing through the studio, including Harrison Ford and Alec Baldwin. The only sounds heard are the clicks of Paolo's camera and the gentle snores from Peter.

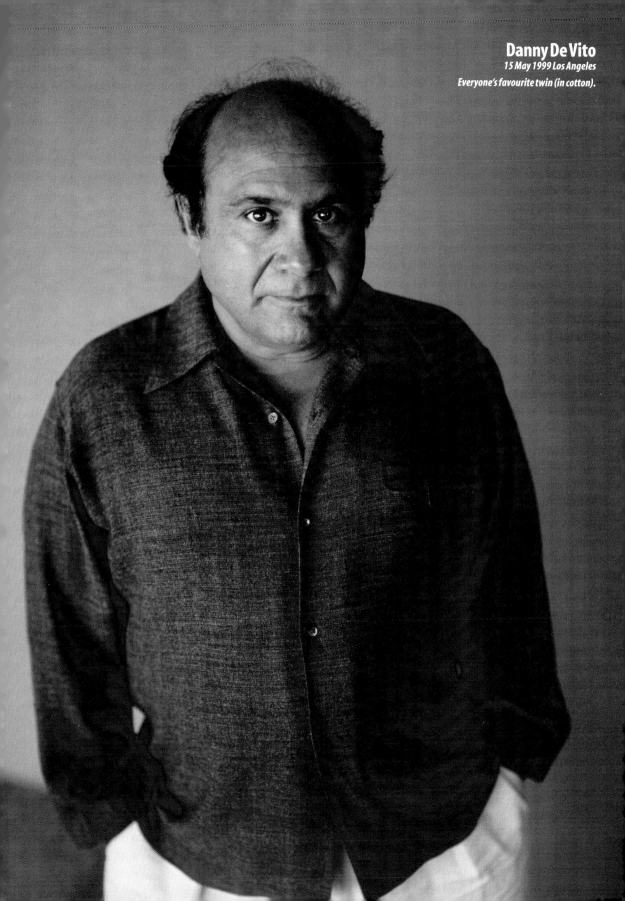

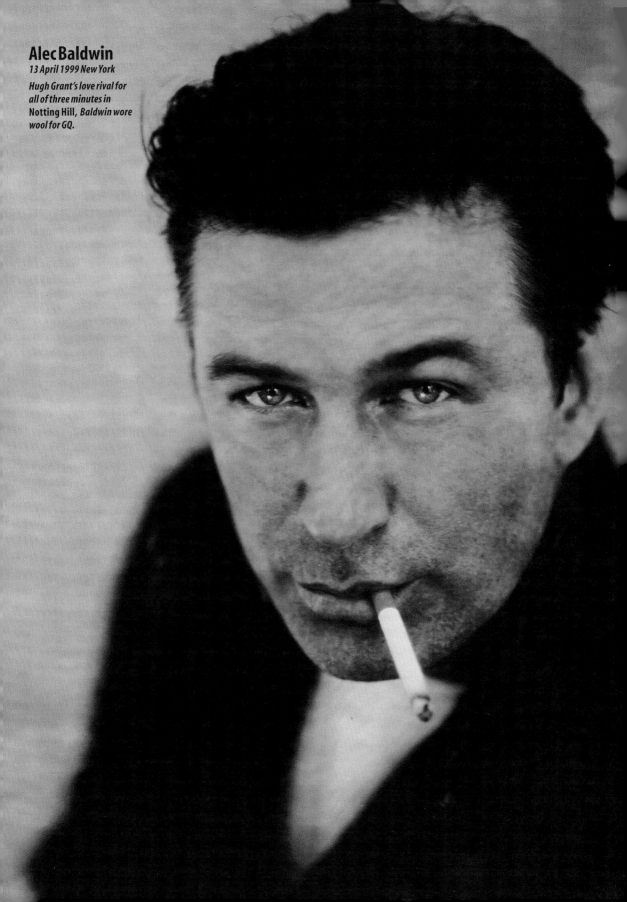

Alec Baldwin
13 April 1999 New York

Hugh Grant's love rival for
all of three minutes in
Notting Hill, *Baldwin wore
wool for GQ.*

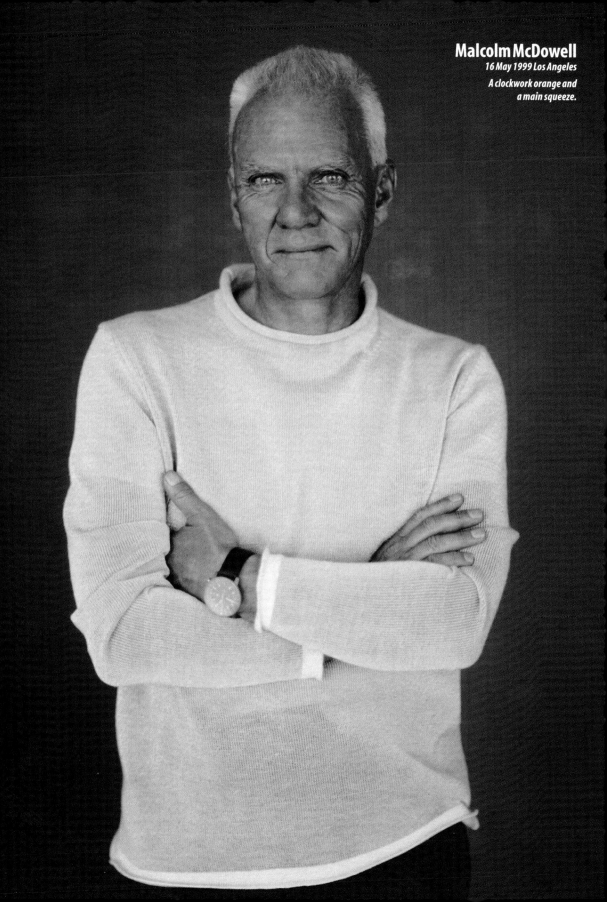

Malcolm McDowell
16 May 1999 Los Angeles
*A clockwork orange and
a main squeeze.*

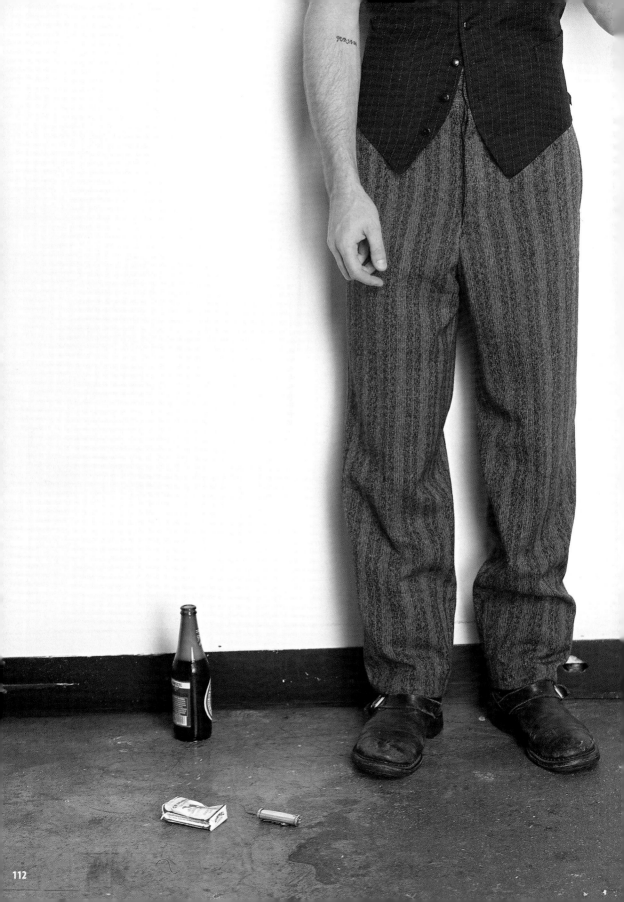

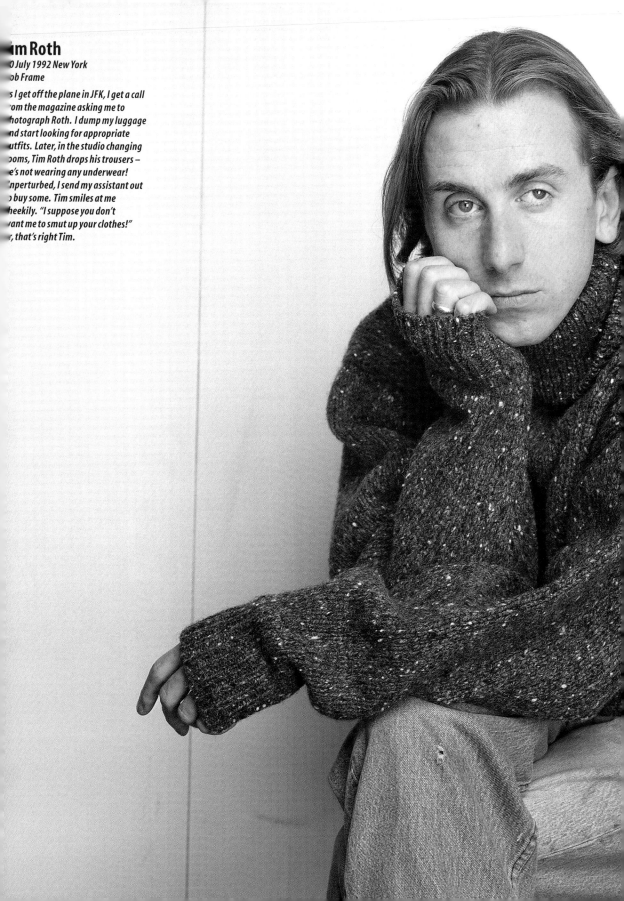

Tim Roth
30 July 1992 New York
Bob Frame

As I get off the plane in JFK, I get a call from the magazine asking me to photograph Roth. I dump my luggage and start looking for appropriate outfits. Later, in the studio changing rooms, Tim Roth drops his trousers – he's not wearing any underwear! Unperturbed, I send my assistant out to buy some. Tim smiles at me cheekily. "I suppose you don't want me to smut up your clothes!" Er, that's right Tim.

sport

01

Is there anything cooler than scoring the winning goal in a World Cup Final, or breaking the 100m sprint record, or experiencing the visceral thrill of snowboarding into oblivion? By their very natures sports stars are cool, whether they're footballers or cricketers, tennis players or gymnasts. So why shouldn't they take some reflected glory as well as some Olympic gold?

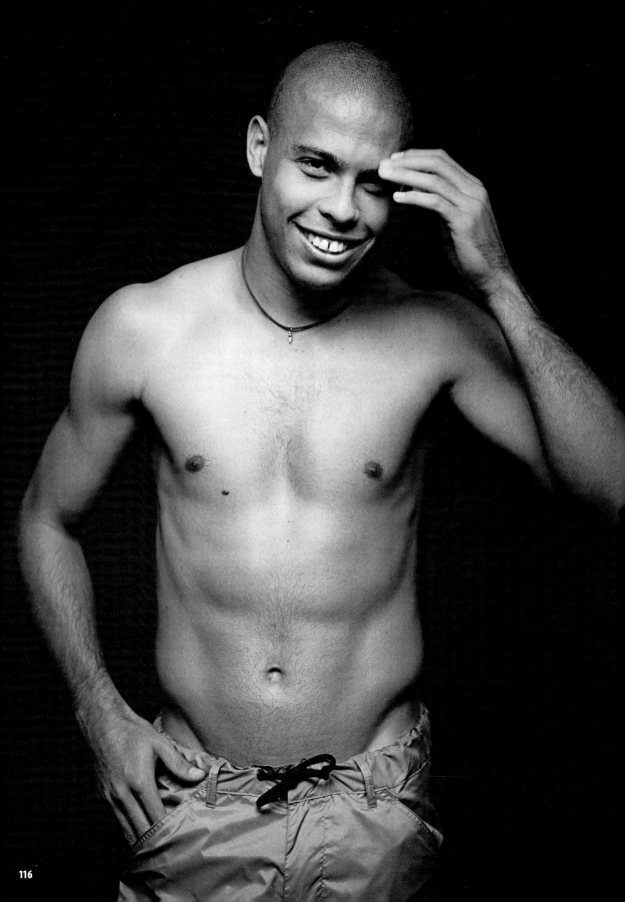

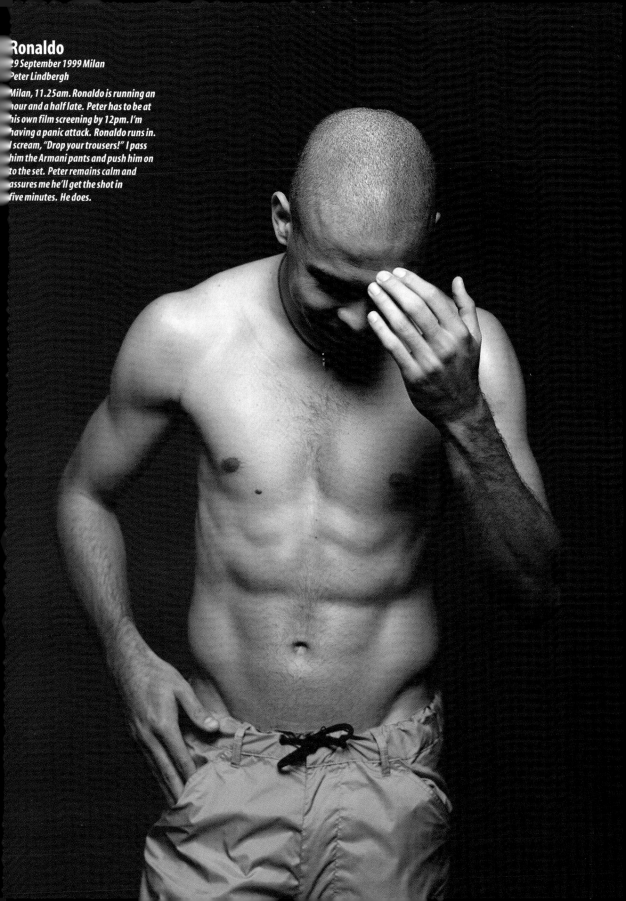

Ronaldo
29 September 1999 Milan
Peter Lindbergh

Milan, 11.25am. Ronaldo is running an hour and a half late. Peter has to be at his own film screening by 12pm. I'm having a panic attack. Ronaldo runs in. I scream, "Drop your trousers!" I pass him the Armani pants and push him on to the set. Peter remains calm and assures me he'll get the shot in five minutes. He does.

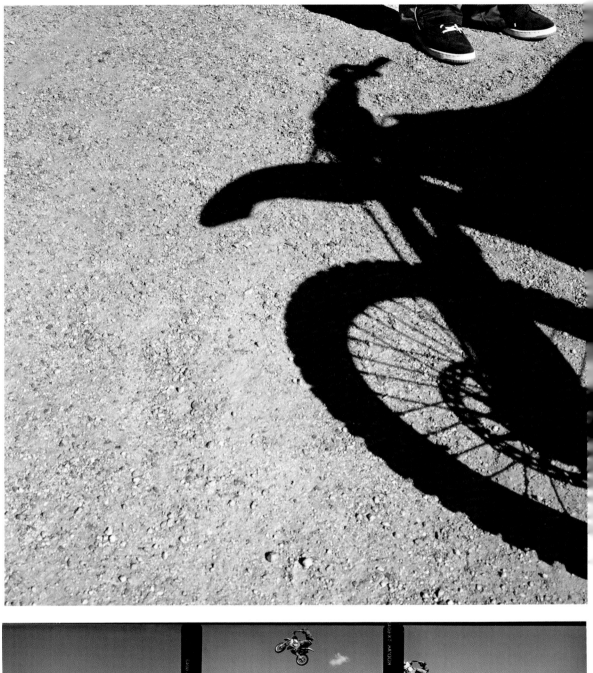

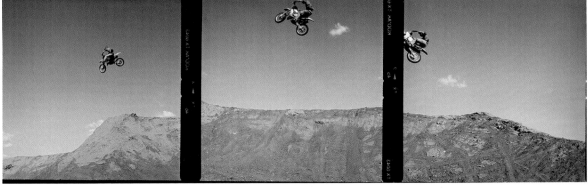

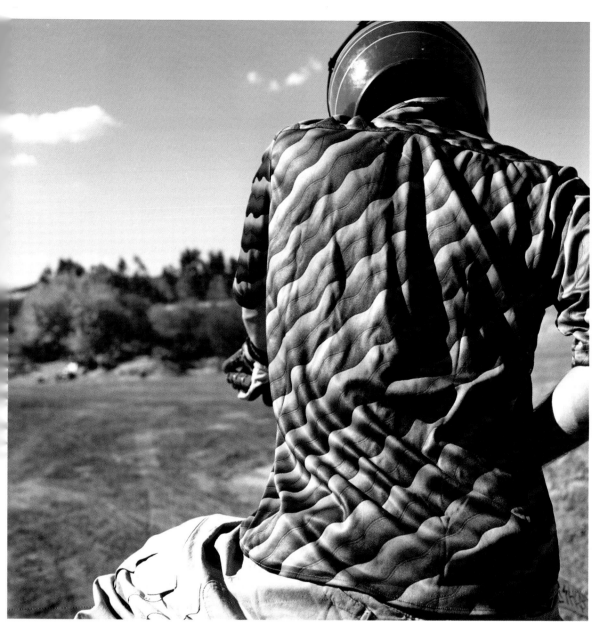

Cross-dressing
12 October 1997 Temecula, Southern California
Julian Broad

Julian (Broad) has a passion for motorbikes
and suggested we do a Motorcross story.
Popularised by Steve McQueen, the sport now
has a cult following, especially in Temecula,
just outside LA, where we shot the bikers.
The whole experience was like stepping into
a David Lynch movie.

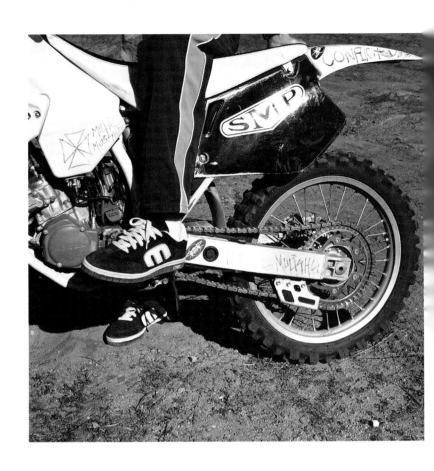

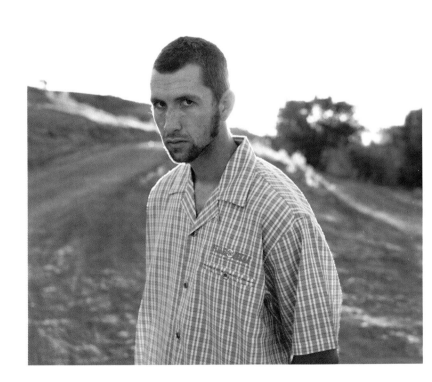

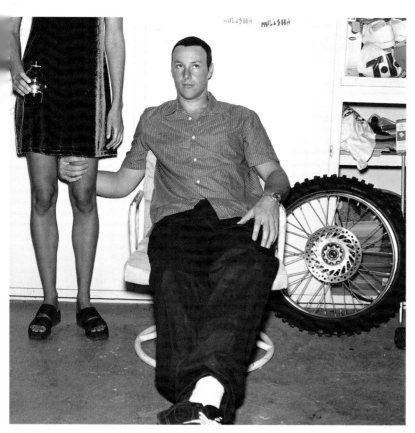

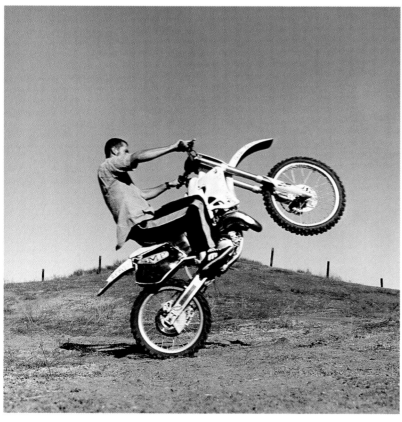

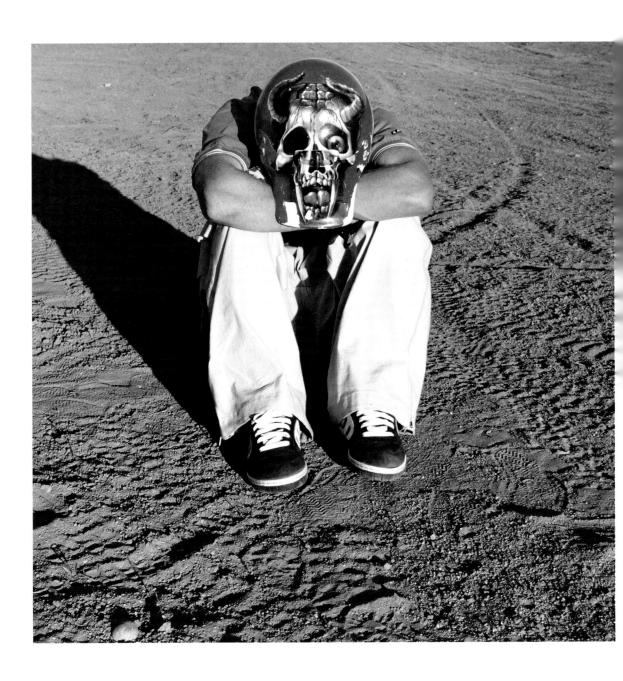

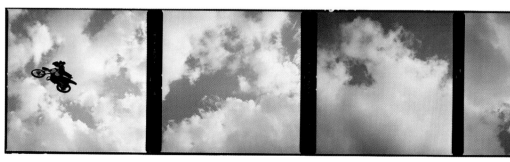

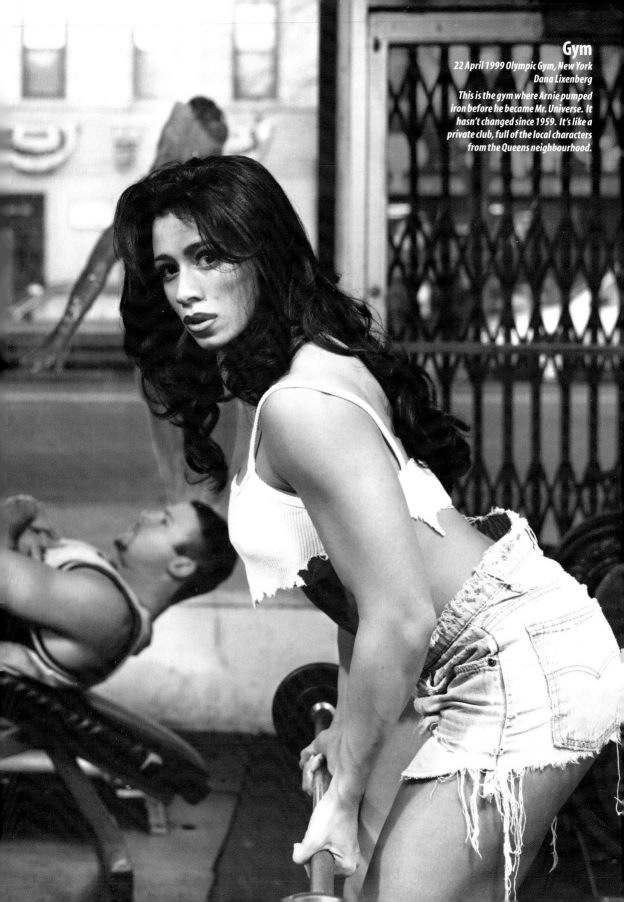

Gym
22 April 1999 Olympic Gym, New York
Dana Lixenberg

This is the gym where Arnie pumped iron before he became Mr. Universe. It hasn't changed since 1959. It's like a private club, full of the local characters from the Queens neighbourhood.

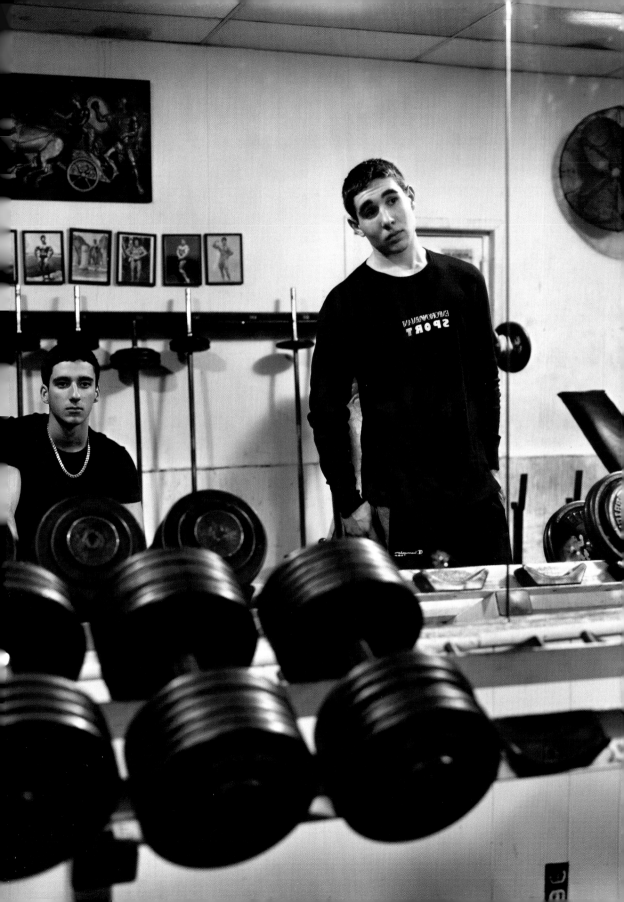

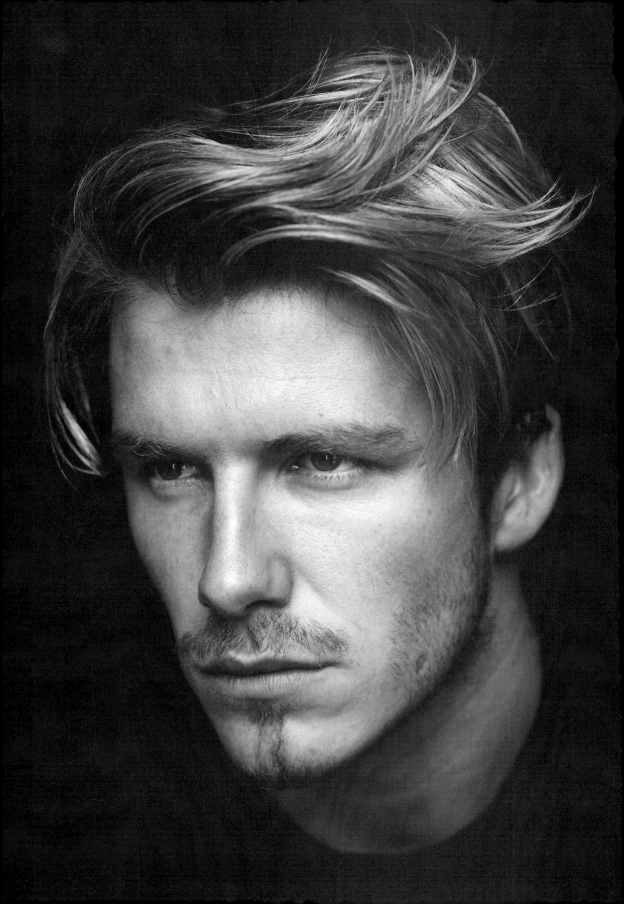

David Beckham
29 May 1999 London
Julian Broad

David had been voted Sportsman of the Year by GQ. He turned up at the studio with his son Brooklyn and then-fiancée, Victoria Adams, who spent the whole afternoon with her mobile glued to her ear making final arrangements for 'that' wedding.

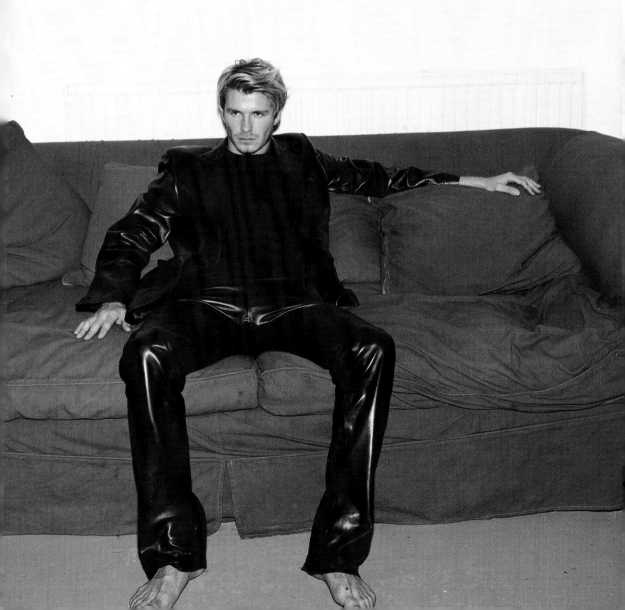

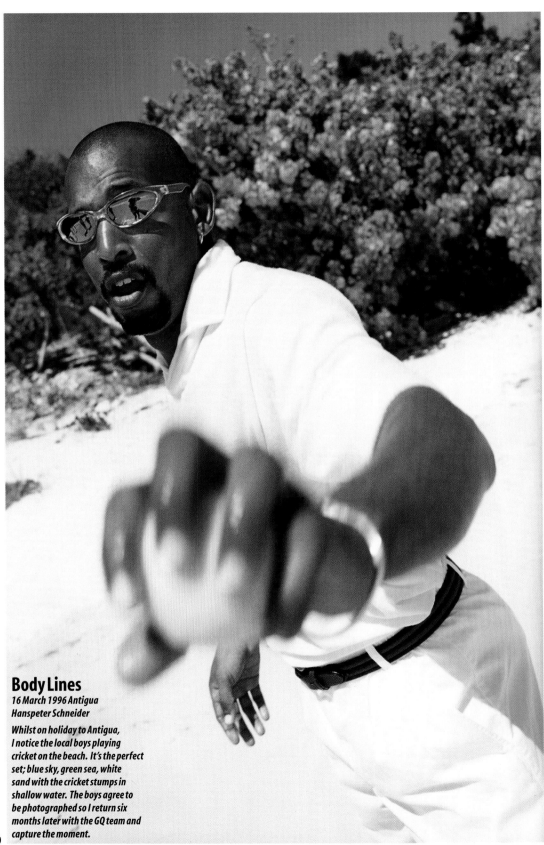

Body Lines
16 March 1996 Antigua
Hanspeter Schneider

*Whilst on holiday to Antigua,
I notice the local boys playing
cricket on the beach. It's the perfect
set; blue sky, green sea, white
sand with the cricket stumps in
shallow water. The boys agree to
be photographed so I return six
months later with the GQ team and
capture the moment.*

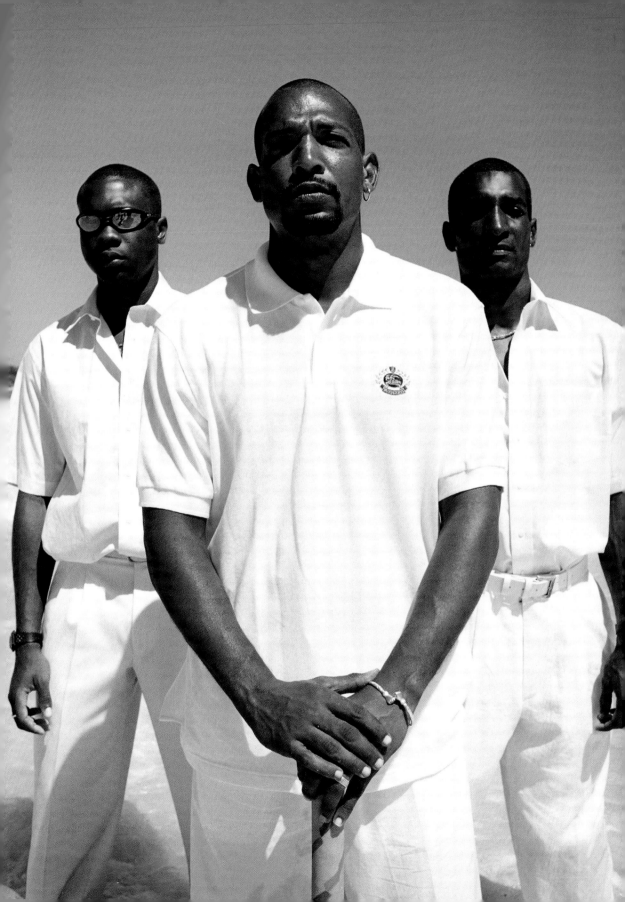

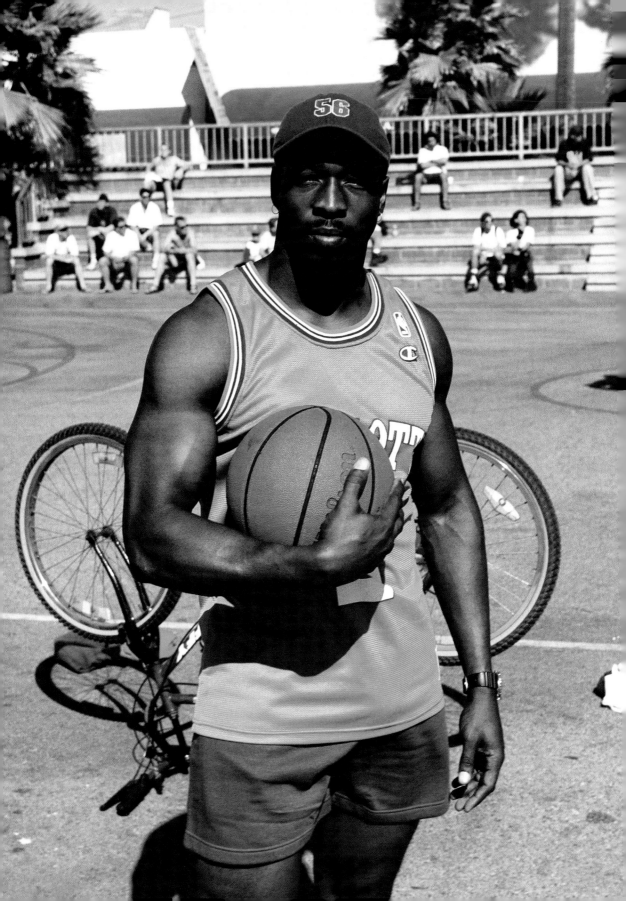

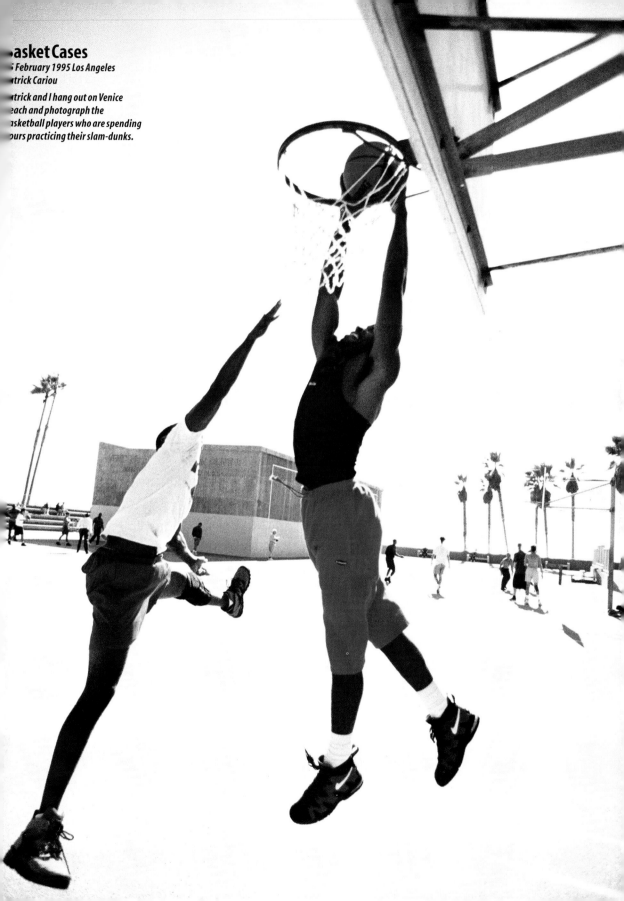

Basket Cases

25 February 1995 Los Angeles
Patrick Cariou

Patrick and I hang out on Venice
Beach and photograph the
basketball players who are spending
hours practicing their slam-dunks.

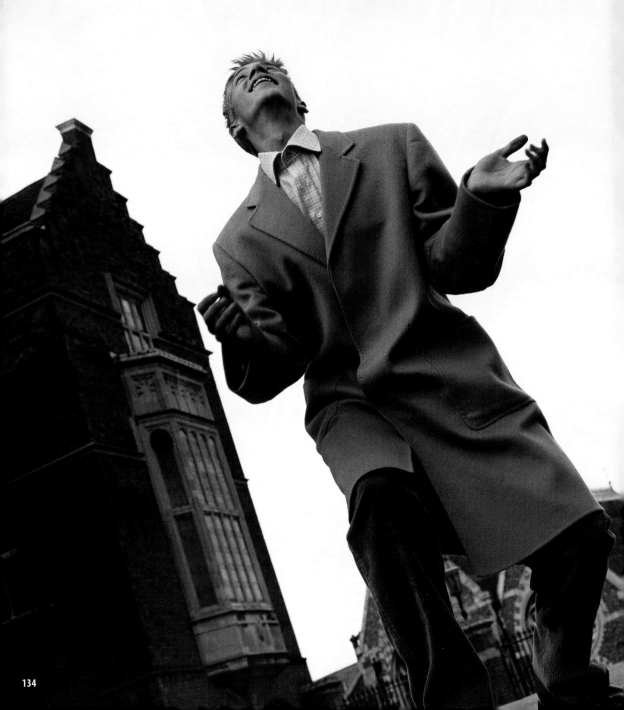

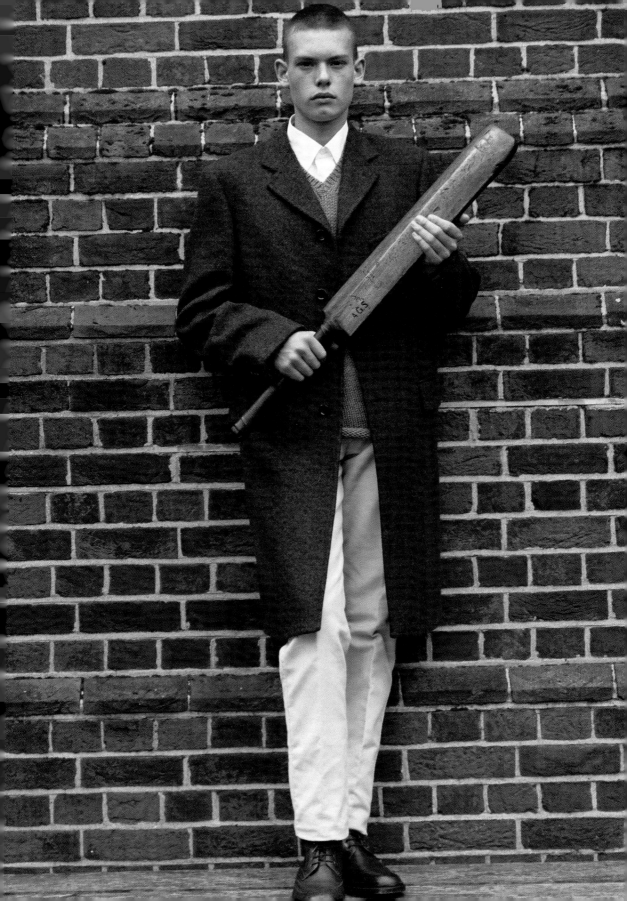

cinema

01

The movie house has always had the capacity to conjure up dreams and wishes, a veritable cathedral of invention. Not only has it been enormously influential too, causing all of us to say, "Yes, well, it was like something out of a movie." Which a lot of these pictures are.

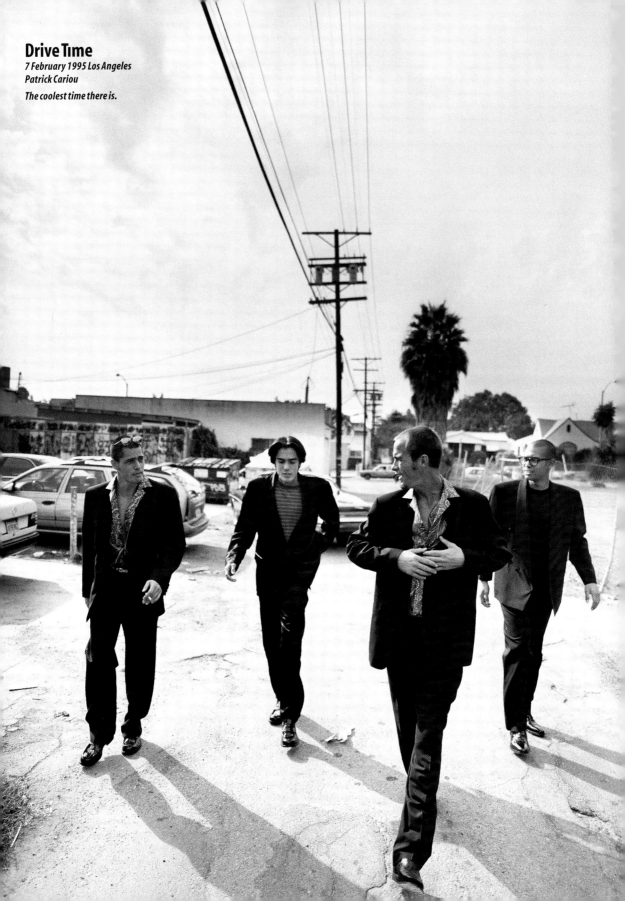

Drive Time
7 February 1995 Los Angeles
Patrick Cariou

The coolest time there is.

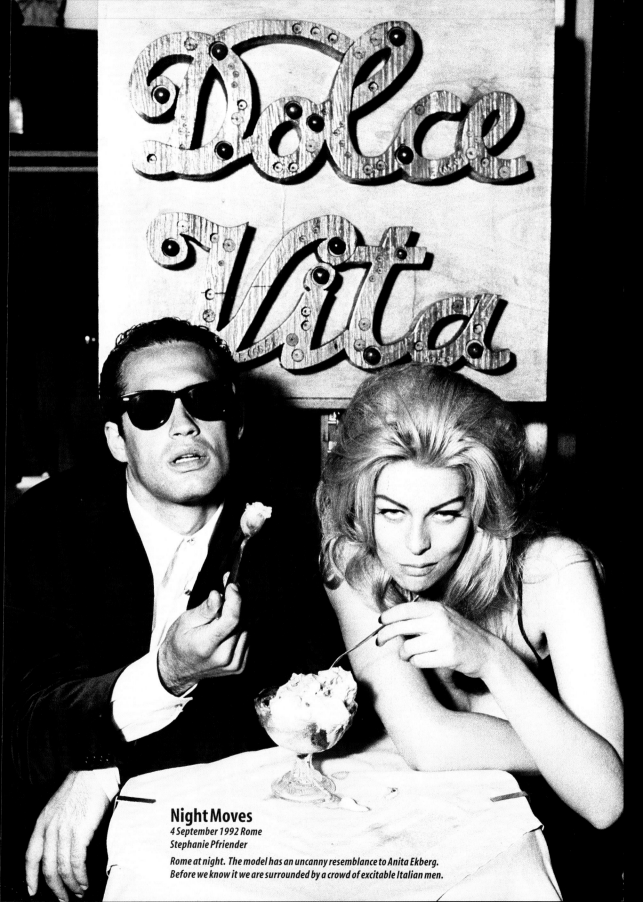

Night Moves
4 September 1992 Rome
Stephanie Pfriender

Rome at night. The model has an uncanny resemblance to Anita Ekberg.
Before we know it we are surrounded by a crowd of excitable Italian men.

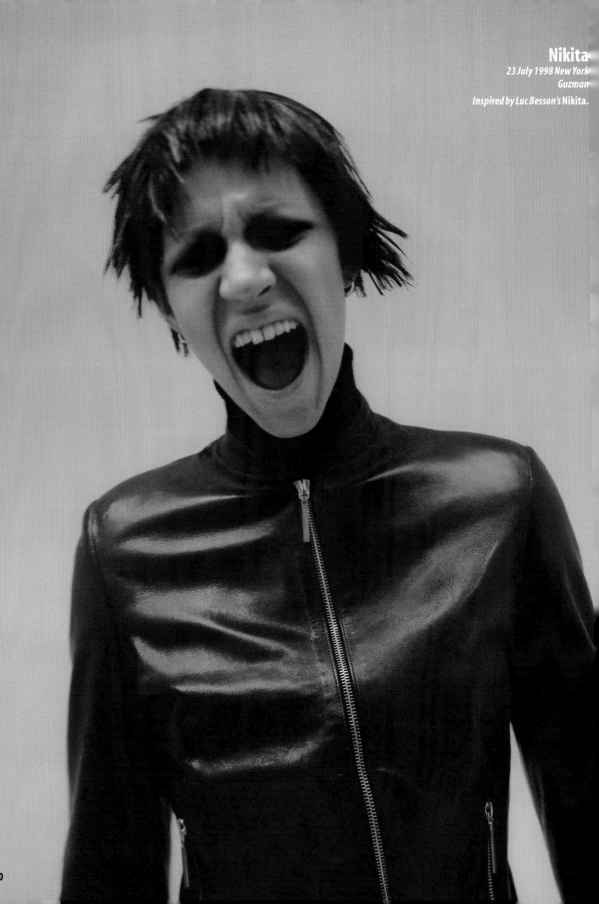

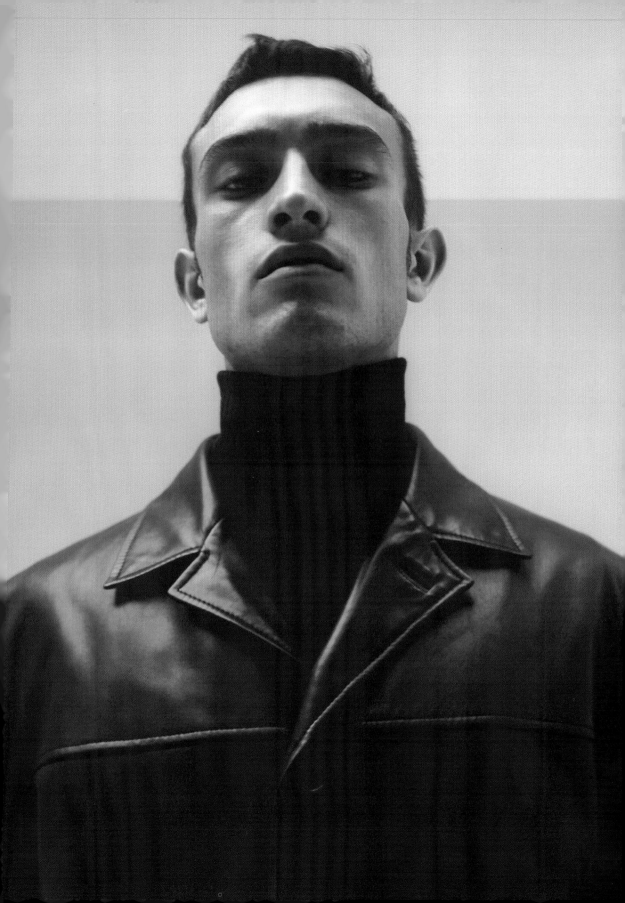

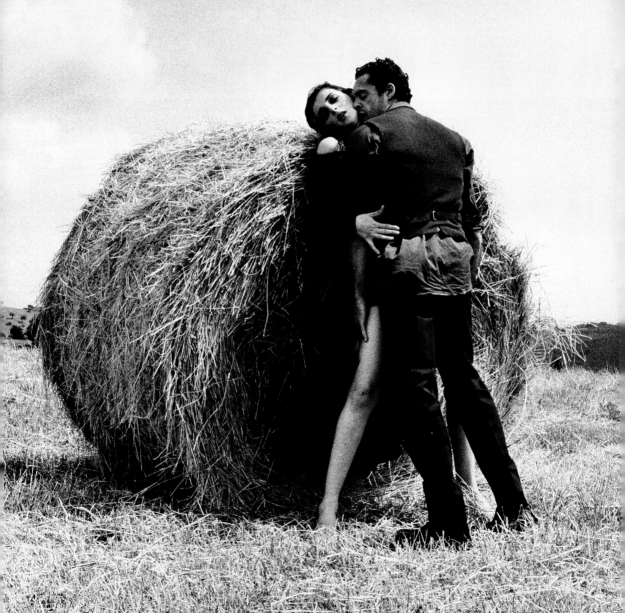

Playing the Field

29 August 1999 Tuscany
Stephanie Pfriender

My first shoot. My inspiration came
from Bertolucci's great film, 1900.

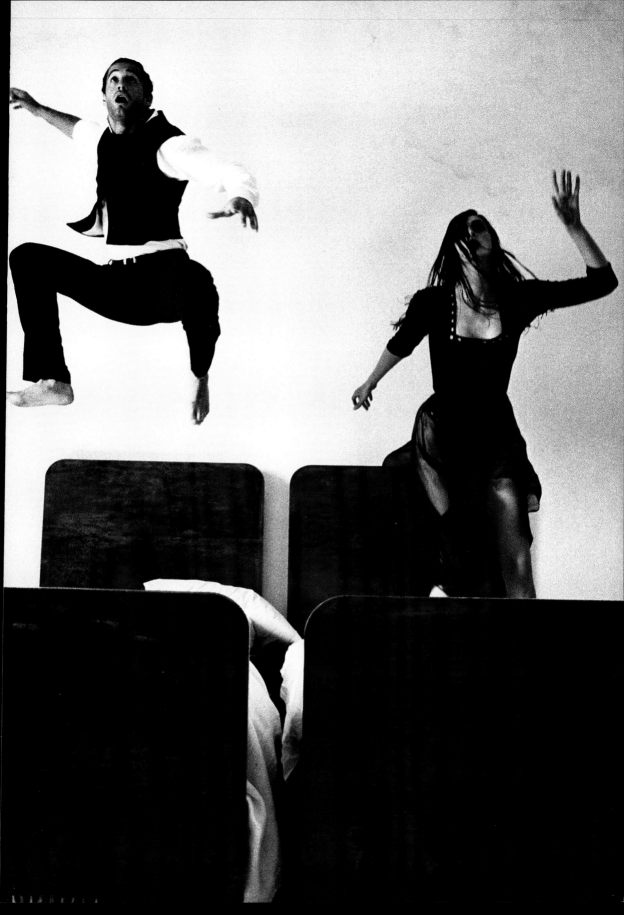

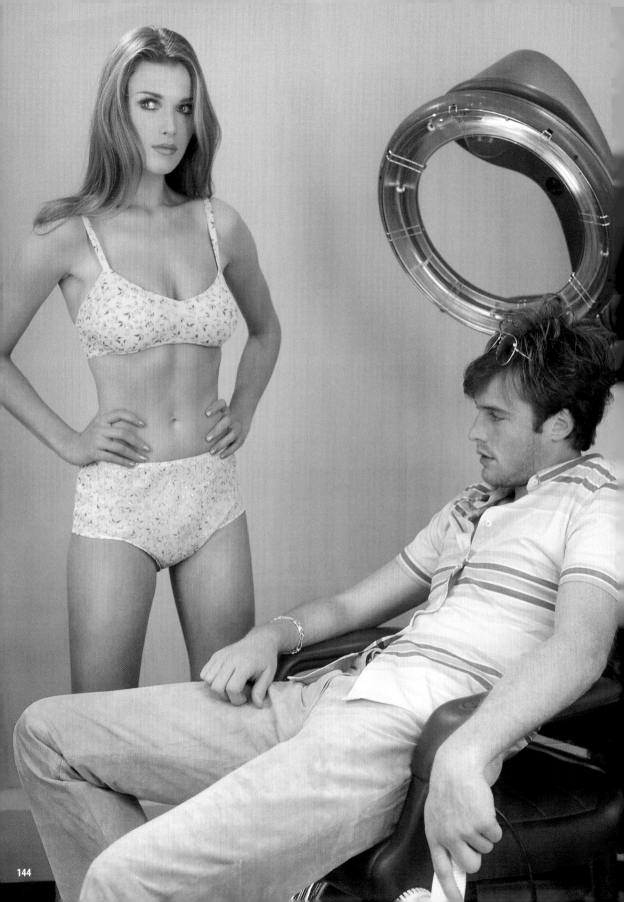

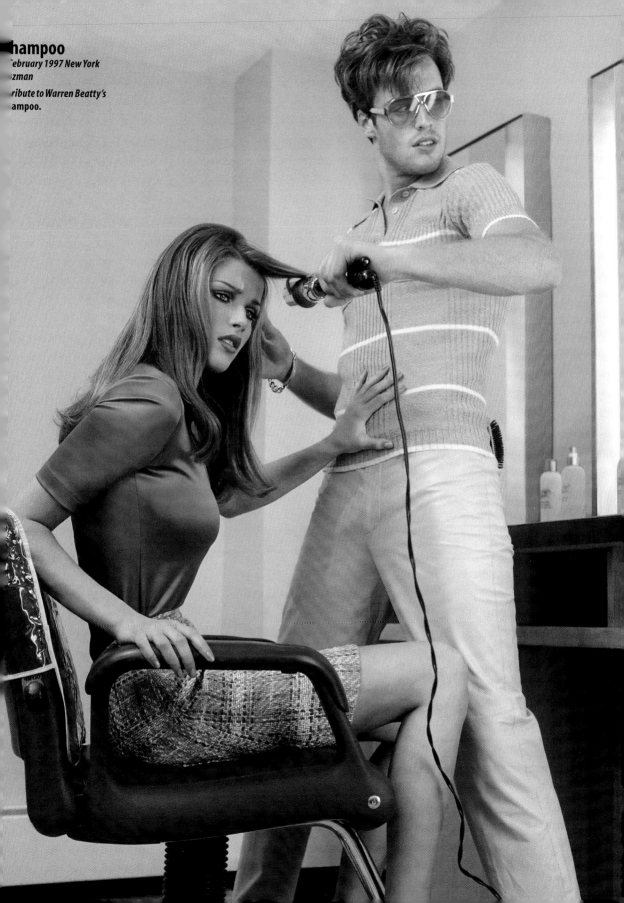

hampoo
February 1997 New York
zman
ribute to Warren Beatty's
ampoo.

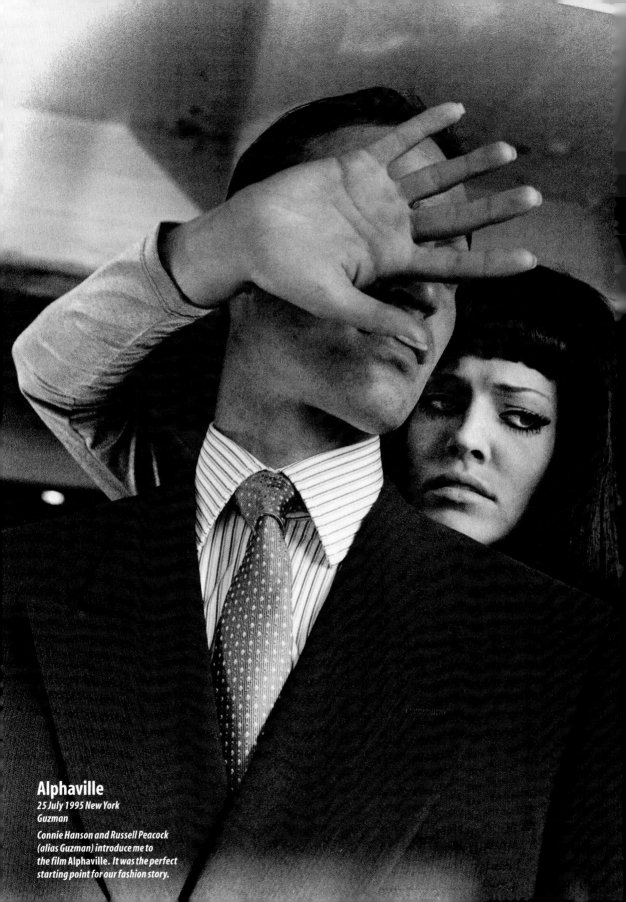

Alphaville

25 July 1995 New York
Guzman

Connie Hanson and Russell Peacock
(alias Guzman) introduce me to
the film Alphaville. It was the perfect
starting point for our fashion story.

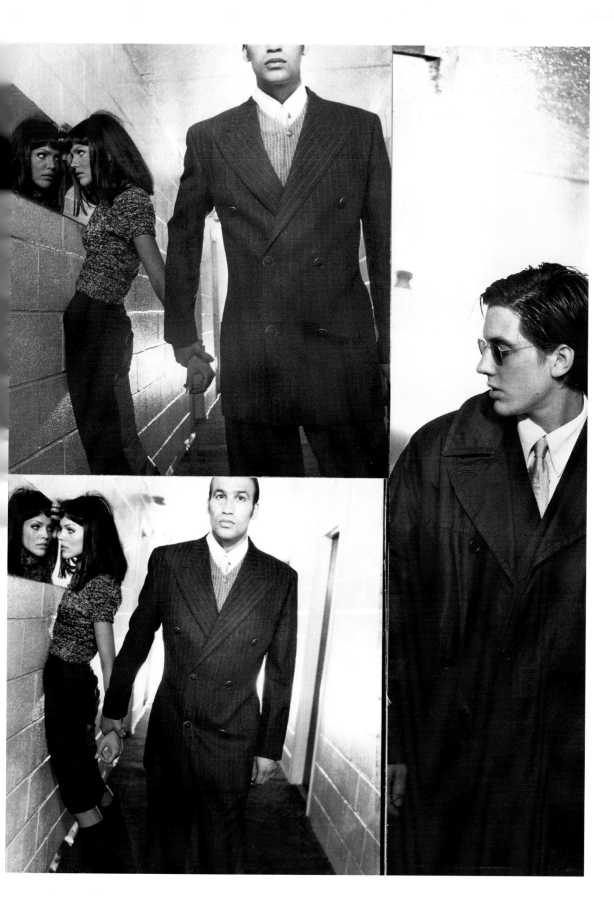

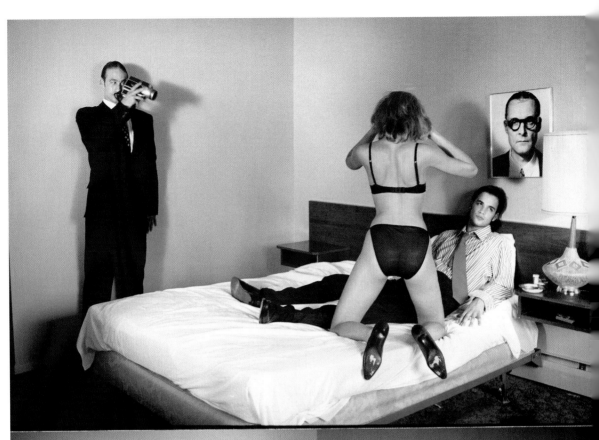

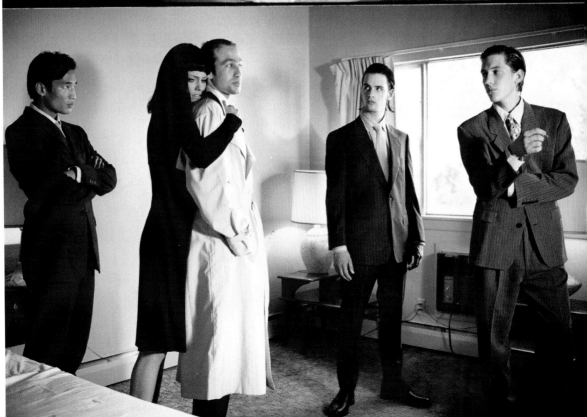

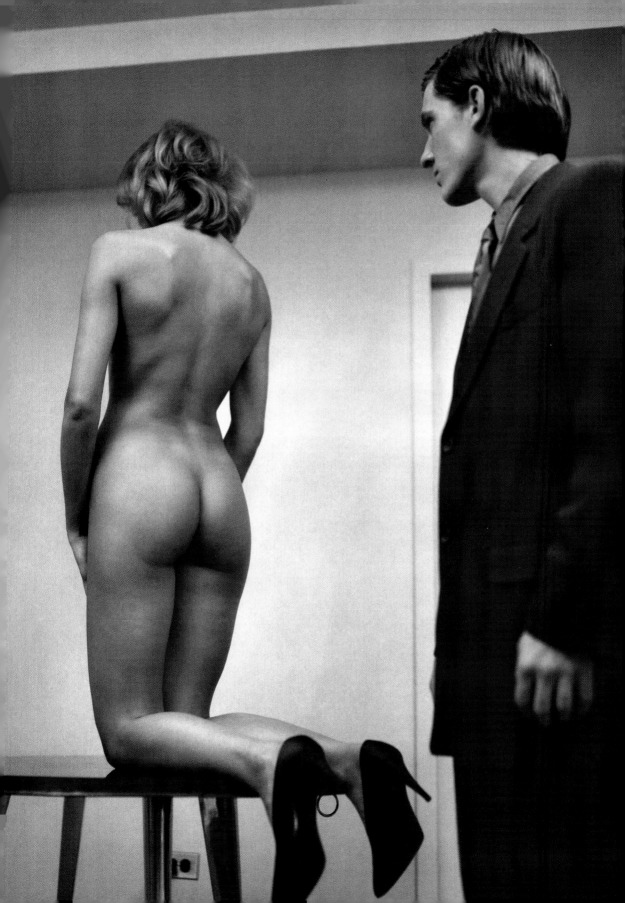

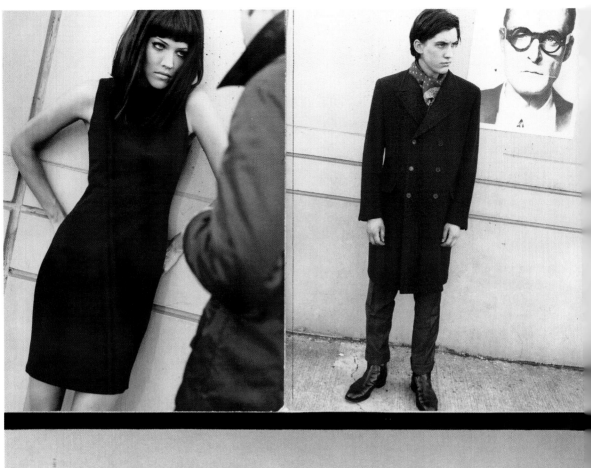
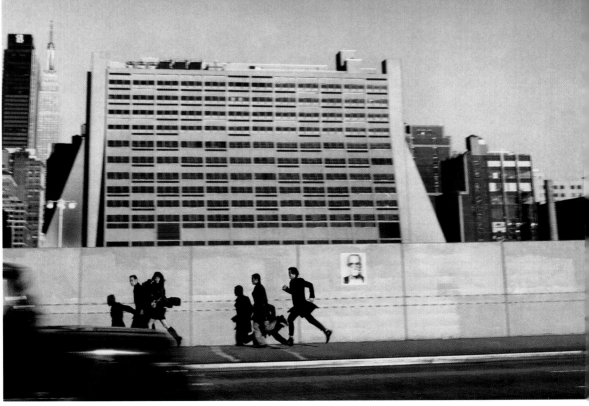

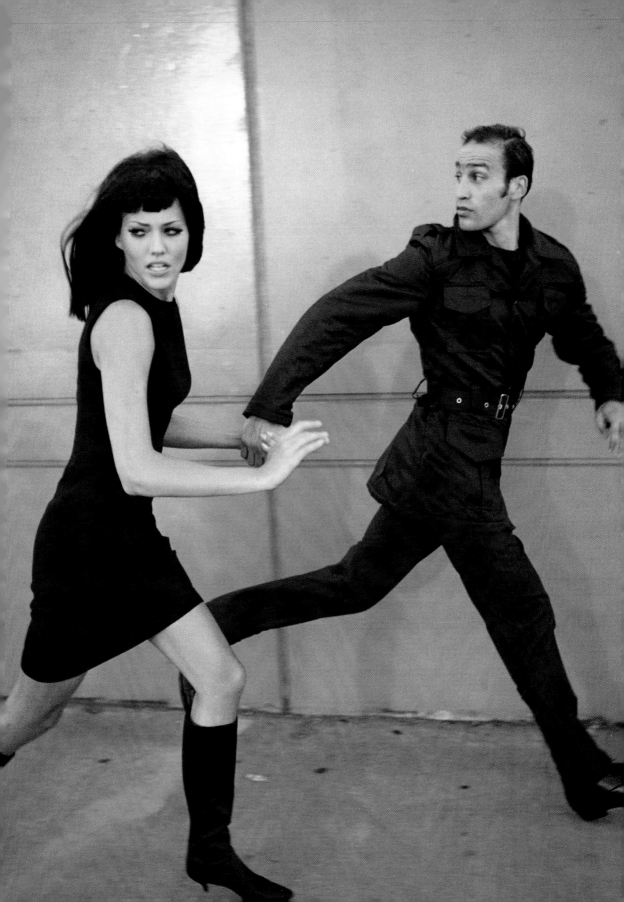

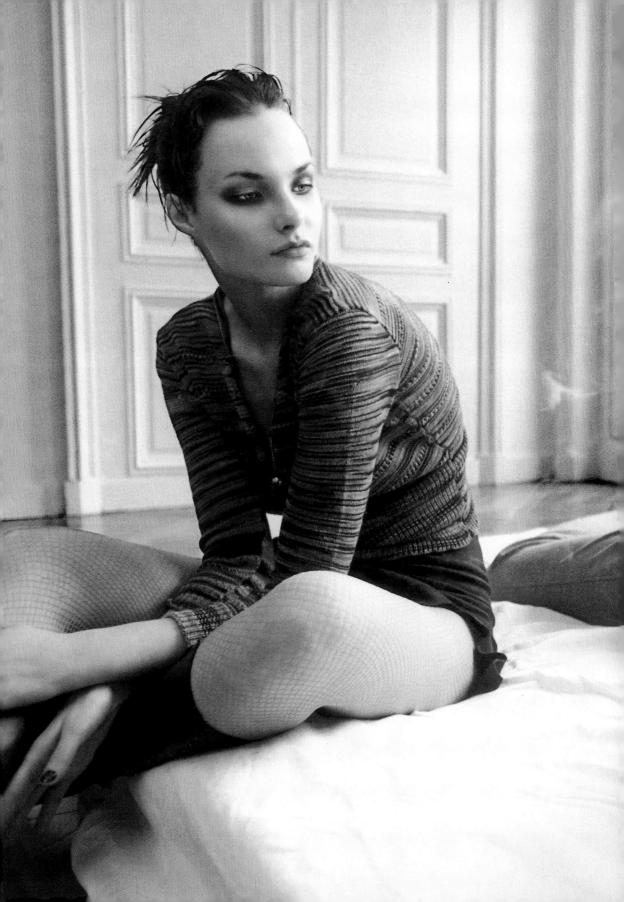

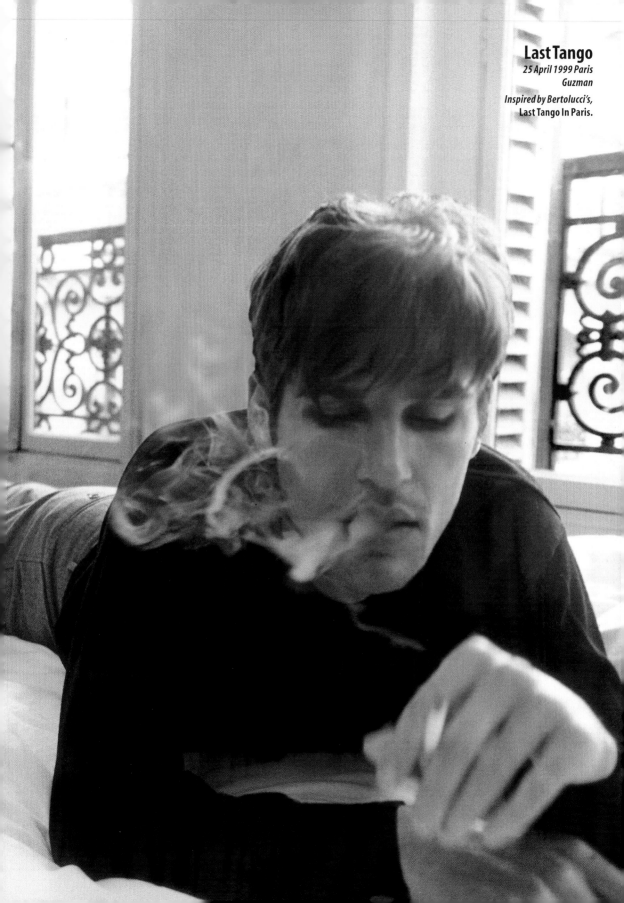

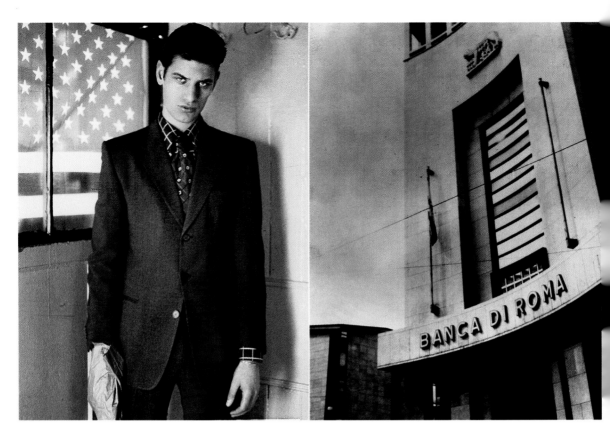

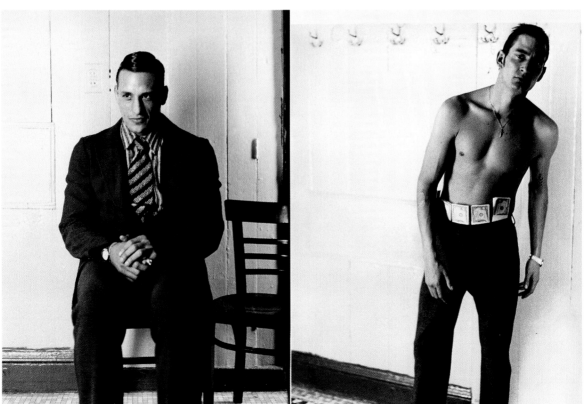

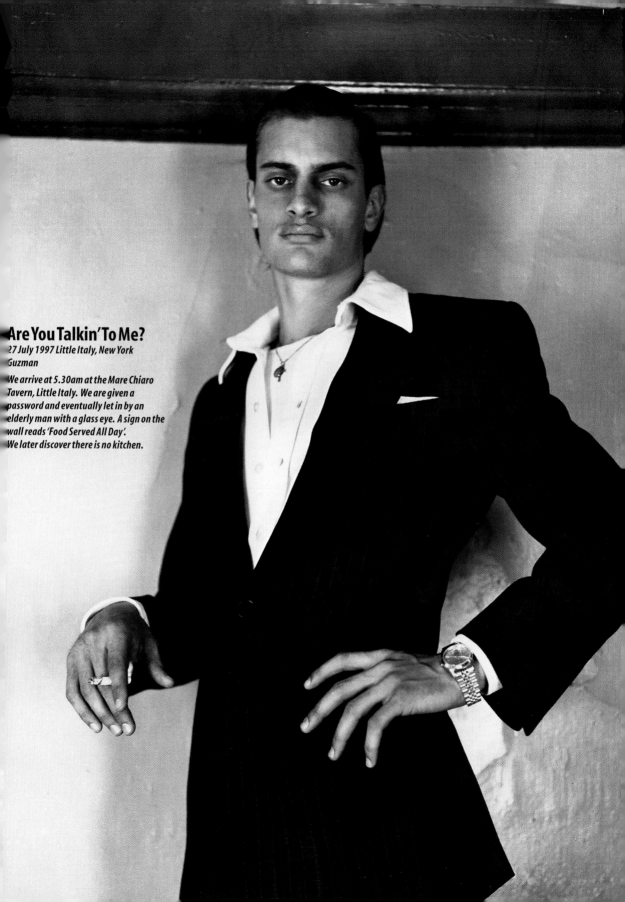

Are You Talkin' To Me?

27 July 1997 Little Italy, New York
Guzman

*We arrive at 5.30am at the Mare Chiaro
Tavern, Little Italy. We are given a
password and eventually let in by an
elderly man with a glass eye. A sign on the
wall reads 'Food Served All Day'.
We later discover there is no kitchen.*

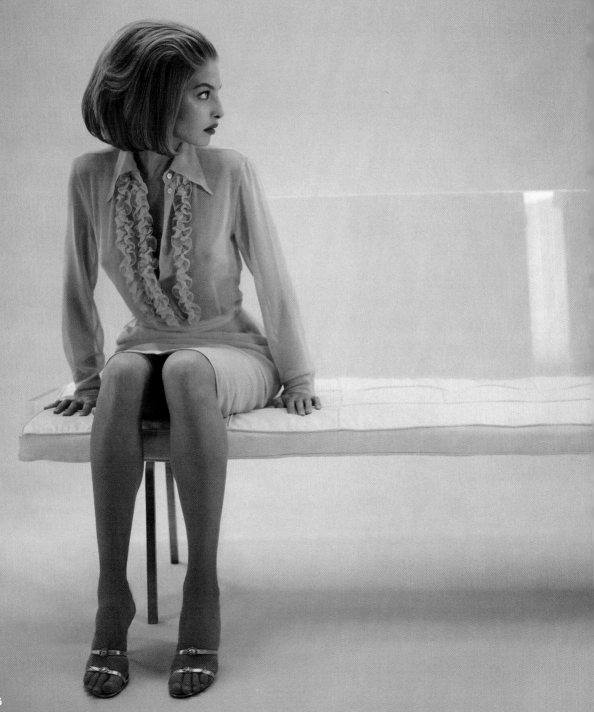

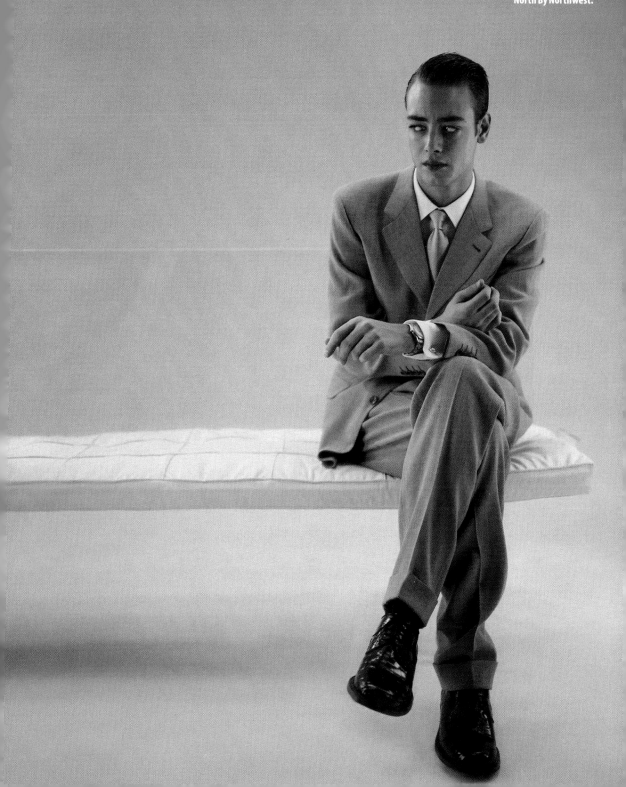

The Director's Cut
20 October 1997 Milan
Guzman
Inspired by the Hitchcock classic
North By Northwest.

David Bowie and Paul Smith
photographed by Peter Robathan

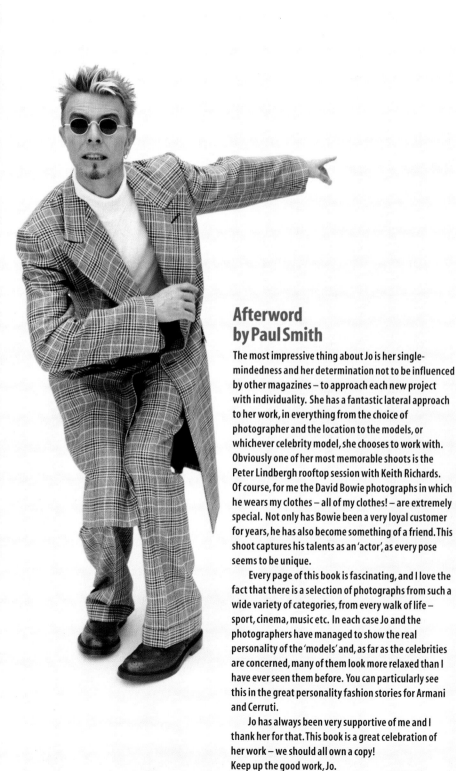

Afterword
by Paul Smith

The most impressive thing about Jo is her single-mindedness and her determination not to be influenced by other magazines – to approach each new project with individuality. She has a fantastic lateral approach to her work, in everything from the choice of photographer and the location to the models, or whichever celebrity model, she chooses to work with. Obviously one of her most memorable shoots is the Peter Lindbergh rooftop session with Keith Richards. Of course, for me the David Bowie photographs in which he wears my clothes – all of my clothes! – are extremely special. Not only has Bowie been a very loyal customer for years, he has also become something of a friend. This shoot captures his talents as an 'actor', as every pose seems to be unique.

Every page of this book is fascinating, and I love the fact that there is a selection of photographs from such a wide variety of categories, from every walk of life – sport, cinema, music etc. In each case Jo and the photographers have managed to show the real personality of the 'models' and, as far as the celebrities are concerned, many of them look more relaxed than I have ever seen them before. You can particularly see this in the great personality fashion stories for Armani and Cerruti.

Jo has always been very supportive of me and I thank her for that. This book is a great celebration of her work – we should all own a copy!
Keep up the good work, Jo.

Thanks

This book would not have been published without
Nicholas Coleridge. I would also like to thank Jonathan
and Ronnie Newhouse for their encouragement and
support, Dylan Jones for his sound advice and brilliant
direction , thank you to Tony Chambers who I love
collaborating with, to the fashion team, Catherine
Hayward, Naomi Hoffmann and Charlotte Wilton-Steer,
to the rest of the GQ team, Bill Prince, Claire Grant, Ash
Gibson, Miles English, Neil O'Sullivan, Sid Pithwa, David
Gyseman for his tireless attention to detail in ensuring
the high quality reproduction of these photographs
when published in GQ. To Angus MacKinnon, Michael
VerMeulen, Peter Howarth, Bill Dunn, Paul Bowden,
Alexandra Kotur, Amanda Gowing, Gareth Scourfield.
Special thanks to David Bowie, Paul Smith, Peter Stuart,
Suzy Menkes, Alexandra Shulman, Dreas Reyneke,
Robert Rabinsteiner, Bob Crowley, Fotini Dimou,
Nicholas Gravelle and Georgina Capel, and finally I
want to thank my brilliant photographers, Olivia
Beasley, Alan Beukers, Koto Bolofo, Gavin Bond, Julian
Broad, Richard Burbridge, Patrick Cariou, Donald
Christie, William Claxton, Matthew Donaldson, Terence
Donovan, The Douglas Brothers, Andrew Eccles, Jillian
Edelstein, David Eustace, Gerald Forster, Bob Frame,
Guzman, Kim Knott, Peter Lindbergh, Dana Lixenberg,
Norman Lomax, Magnus Marding, Desmond Muckian,
Stephanie Pfriender, Tim Richmond, Peter Robathan,
Paolo Roversi, Hanspeter Schneider, Laura Wilson,
Stephan Ziehen.